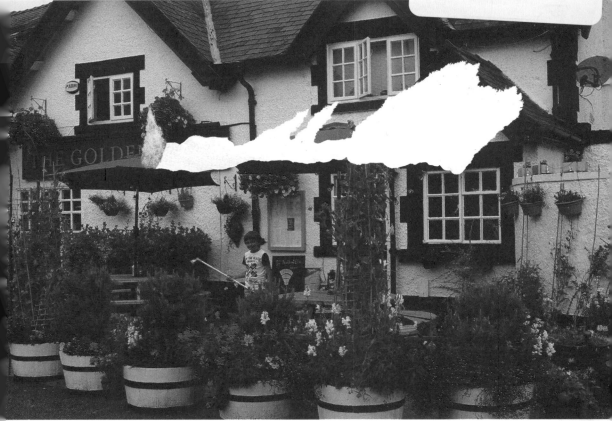

The Golden Lion, Rossett.

Also available from Amberley Publishing

Explore Wrexham's secret history through a fascinating selection of stories, facts and photographs.

978 1 4456 7700 2
Available to order direct 01453 847 800
www.amberley-books.com

50 GEMS OF
North Wales

JOHN IDRIS JONES

AMBERLEY

First published 2018

Amberley Publishing
The Hill, Stroud
Gloucestershire, GL5 4EP

www.amberley-books.com

British Library Cataloguing in Publication Data.
A catalogue record for this book is available from the British Library.

ISBN 978 1 4456 7328 8 (paperback)
ISBN 978 1 4456 7329 5 (ebook)

Origination by Amberley Publishing.

Printed in Great Britain.

Contents

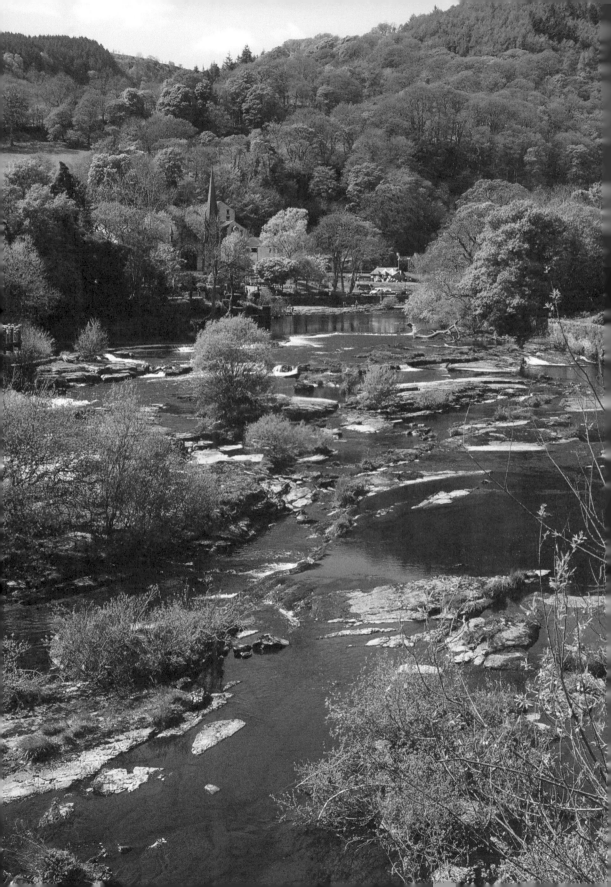

Introduction

A gem is a precious stone, especially when cut and polished. Its figurative meaning indicates something valued because of its excellence or beauty. So it is something that stands out; it is out of the ordinary. Many areas of the UK are ordinary, having a singularity of landscape and architecture, but North Wales is different: it has variety and diversity. There are mountains, hills and buildings; villages and towns that have their own style and identity; chapels, active and inactive, as a product of a distinctive nonconformity in religion; seascapes along its northern and western borders that vary from handsome bays to rocky inlets; and the remains of the slate and coal industries to the extreme west and east, with slate still part of the economy. It has an indigenous language that has left its mark on the naming of features and places. The sense of sight is very active in North Wales; scenery dominates. The camera captures sights. The beauty of place and structure can be captured, such as the bridge in Llanrwst. However, stories are also here in abundance. To have a record of human activity, there needs to be an account, a narrative, such as the story of the *Alice in Wonderland* connection with Llandudno. Dominating this was slate in the west and coal in the east. In Wrexham, we have the remains of extensive coal mining, with, once, employment for thousands. The terrible tragedy at the Gresford colliery is part of local folk memory.

Sometimes our gems are small scale, not landscapes and rural views but items such as the hand-made miniature locomotive *Topsy*, on display in the café at the Ffestiniog railway station at Porthmadog. In Wrexham we observe a gateway to an exhibition that has a memorial plaque in memory of the local man who came up with a practical scheme for a Channel Tunnel inside. These are stories behind the pictures; North Wales is rich with them. The author hopes that the following presentation of pictures and accounts will truly represent a part of the United Kingdom that contains much gem-like beauty and is fascinating in its diversity and character.

(The author wishes to thank Tom Gregg of Ruthin for contributing five of his excellent photographs of North Wales.)

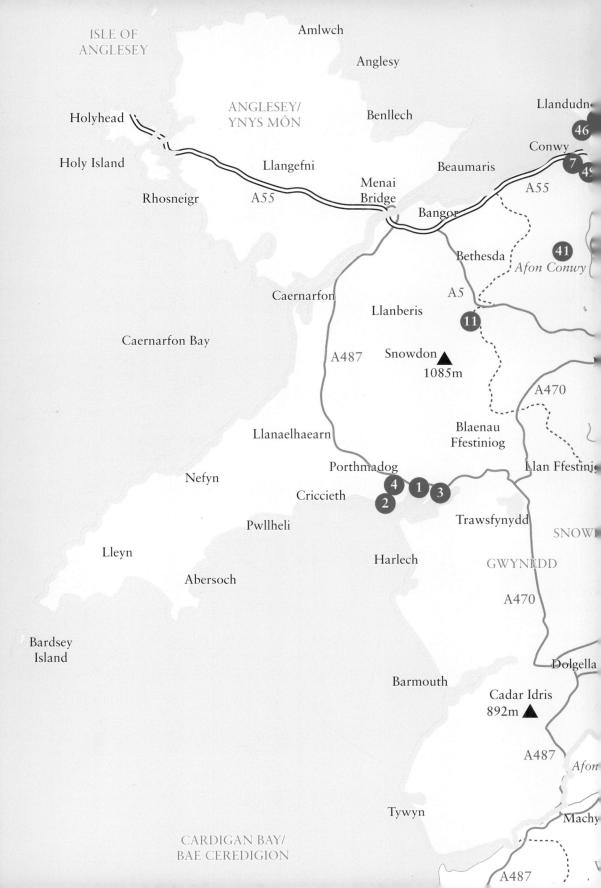

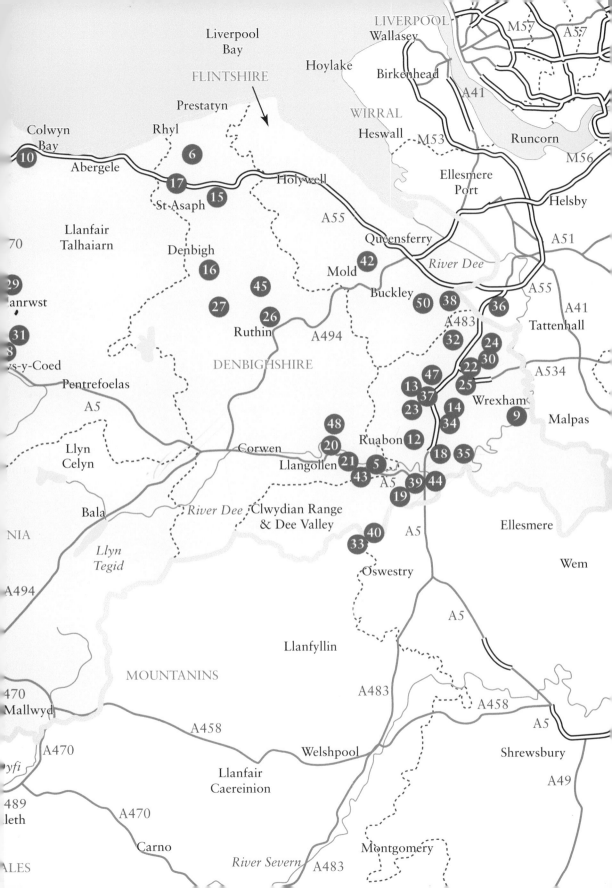

1 The Harbour, Porthmadog

The harbour is the hub of Porthmadog. Created in the early nineteenth century by William Alexander Madocks and his faithful partner John Williams, the harbour was created when the River Glaslyn changed its course after the first embankment was built. This diverted seawater away from the bay, making the dry land of Penmorfa, Prenteg and the site of the newly built Tremadog.

Industrial activity started with slate at Ffestiniog needing a way to market. The River Dwyryd, running through Maentwrog down the Vale of Ffestiniog, was initially the conduit along which slate was carried on barges, taking it out to sea to be loaded on to cargo ships off Morfa Bychan. However, this procedure was difficult and expensive. A more direct route emerged with the building of the route for the narrow-gauge railway in the 1830s, an extraordinary feat of human effort and endurance, over 13 miles. The trucks were first set to travel down the gradients by gravity, being drawn back by horses. Slate was stored around the harbour and along the riverside where the rivers Glaslyn and Dwyryd merged. Shipbuilding became concentrated around the harbour and at other inlets. The spit of land called Rotten Tare, on the eastern side of the harbour where the recent housing development now sits, became busy with shipbuilders. Slate had found a way to market, and the River Elbe at Hamburg, Germany, soon saw a regular stream of Porthmadog ships delivering slate. To this day parts of Hamburg are roofed with Porthmadog slate. Over 250 sailing ships, mostly two- and three-masted schooners, were hand-made in Porthmadog and its vicinity, ending with the First World War. Photographs of the harbour taken in the 1870s and '80s show the harbour full of ships taking in their cargo of slate, ready to sail to Germany, Spain, Italy, North and South America, and sometimes even to the very distant San Francisco. It was a maritime achievement of epic proportions.

Adjacent to the harbour is the station of the Ffestiniog Railway. The rails go off in the Caernarfon direction to the north-west, and towards Penrhyndeudraeth to the east, over the second-built embankment, known as 'The Cob'. (The town's name describes its geography – the headland with two beaches). On the eastern side of the harbour, up against the hillside, is the original business and manufacturing centre of the railway, Boston Lodge, where high-level engineering took place. The first locomotives were bought, manufactured in London, but in the later decades of the nineteenth century Boston Lodge saw the manufacture of

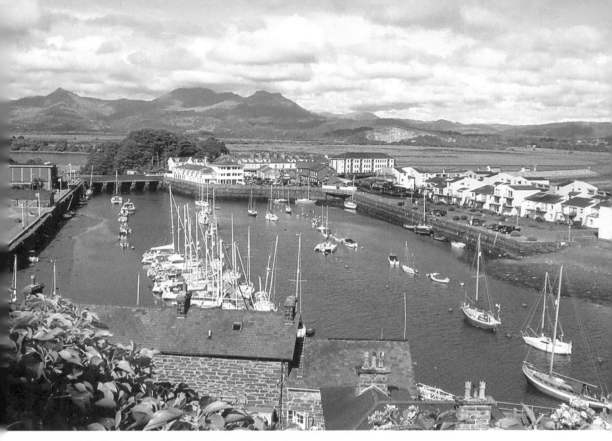

The harbour at Porthmadog with the river estuary.

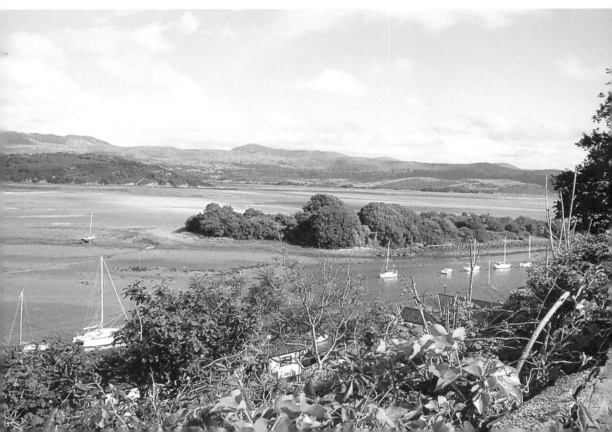

entire engines, the Spooner and Williams families being prominent. Porthmadog people were proud of their self-made trains.

Lt-Col Henry Hughes wrote two excellent books about Porthmadog and its sailing history. He writes in *Through Mighty Seas* (Stephenson, 1975):

> local people started to make a port and build ships. Much mud was scooped from the bed of the River Glaslyn to form a pretty harbour for accommodating incoming ships, rock was torn and blasted from the rugged sides of the hills to make wharves and quays; shipbuilding yards, repairing benches seemed to drop from the clouds. Locomotives whistled around the corners. Sailors and pilots, carpenters and riggers filled the foreshore, ship's chandlers and brokers opened their doors. The resounding din of the caulking mallet mingled with the wail of the gulls and the screech of the noisy crows.

In the background are the mountains Moelwyn Mawr (2,527 feet) and Moelwyn Bach (2,334 feet). To their left is Cnicht (2,265 feet) – almost impossible to pronounce if you are not brought up Welsh-speaking! William Condry writes, 'Cnicht is deservedly one of the most popular lesser mountains of Snowdonia, its sharp ridge being just the height for a day's scramble with the family. As a viewpoint it is excellent; and as part of the view from the Portmadoc side it is superb for then it is end-on and appears as a slender peak; "The Matterhern of Wales" as the guide-books have it.' (*The Snowdonia National Park*: Collins, 1966)

Mount Snowdon at 3,561 feet (the tallest in England and Wales) is behind out of the picture.

2　Borth-y-Gest

This charming village is close to Porthmadog on the Criccieth side. It grew early in the nineteenth century because it was a favoured home for retired sea captains and mariners. Ralph Street was one of the earliest to be built. At one time, the residents displayed their ship's flags from their front gardens. It is relatively unspoiled, and a valued temporary summer home for visitors.

The tall buildings at the edge of the bay are named Tai Pilots because the pilots who went out to sea lived here, over the 'bar', to guide visiting vessels safely through the sand-filled estuary into the harbour at Porthmadog.

On the Porthmadog side of the bay is a row of stylish detached houses, designed by a local architect in 1938. Below them is the site of where the sailing ship the *Blanche Currey* was built in 1875 by Richard Jones, a

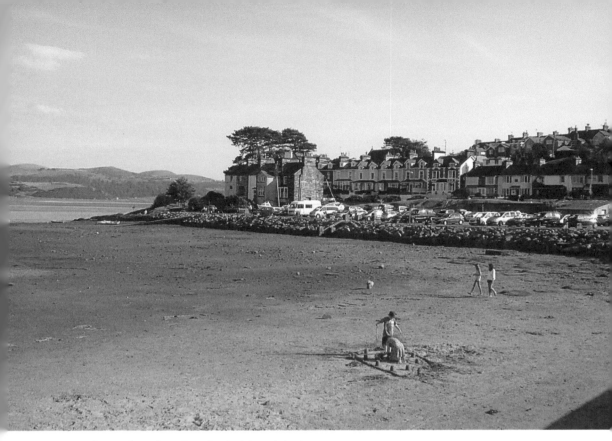

Village of Borth-y-Gest, both sides of the bay.

self-taught designer-builder of Garreg-Wen. Across the bay, where the stored boats and the parking ground for vehicles are now, are two sites of the original shipbuilding. The 'luxury' barque *Pride of Wales* was built here in 1870 by Simon Jones and his team; she was 125 feet long. She spent most of her time on the Indian Ocean.

On a side note, who discovered America? Was it Christopher Columbus or someone earlier? Was it the Welshman Madog, son of the Prince of Gwynedd in the twelfth century (born 1145)? Did he stay there after his second voyage? He is said to have come against his brothers in the distribution of lands, and he determined to find new territories, and that he sailed from the Glaslyn mouth, found his new land, and came back home. Others sailed with him on his second voyage, but none returned. Between Porthmoadog and Tremadog there is a small island in the Glaslyn Estuary called Ynys Fadog (Madog's Island).

3 Ffestiniog Railway

This narrow-gauge railway runs on rails 1 foot 11.5 inches wide, travelling 13.5 miles from Porthmadog to Blaenau Ffestiniog. The Festiniog Railway Co., the owner, is the oldest surviving railway company in the world. In 2011, a second line, the Welsh Highland Railway, was opened to run to Caernarfon. It is 40 miles from Blaenau Ffestiniog to Caernarfon. The line to Blaenau Ffestiniog was opened for business (carrying slate) in April 1836. It was horse drawn – steam engines were not introduced until the 1860s. The gradient is 1:80. The first locomotive was *Mountainee*r, the second *The Princess* (both made in London). In the 1860s the manufacturing of locomotives and carriages took place in Boston Lodge, Minffordd, and in 1869 the first home-built double-Fairlie locomotive was engineered here.

The locomotive *Earl of Merionth II* is the second of this name and is a 0-4-4-0 Double Fairlie. Its original was the third locomotive to be built by the Festiniog Railway Co. at its own workshops at Boston Lodge. Construction of the present engine began in 1972 and was completed in 1879. Its Welsh name is Iarll Meirionnydd. It was converted to coal in 2006. She is capable of hauling twelve coaches.

In the photograph, this engine is approaching the Ffestiniog railway station at Porthmadog, having travelled from Blaenau Ffestiniog and finally over the Cob, the causeway, which also carries the main road to Penrhyndeudraeth.

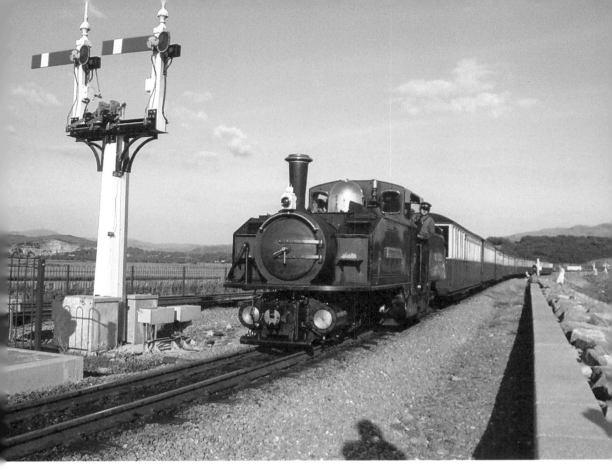

The Ffestiniog Railway, Porthmadog.

4 Topsy

The miniature engine *Topsy* was hand-made by William Williams and his engineering team at the Ffestiniog Railway, Porthmadog, working at Boston Lodge, Minffordd, in 1869/70. The size of a small terrier dog, she runs on four 18-inch gauge rails. It is fed by small pieces of coal and created steam just like a standard internal combustion engine.

Charles Spooner's house, Bron-y-Garth, on the top road from Porthmadog to Borth-y-Gest overlooking the estuary, saw this remarkable locomotive run around the garden – to the amazement of guests. William Williams made his own tools for this job, including a brass spirit level, which remains in the possession of his descendants. The engine is held in a glass case in the Ffestiniog Railway's restaurant Spooners at the station, Porthmadog. It is considered by engineers as an exceptional construction, unique in the world.

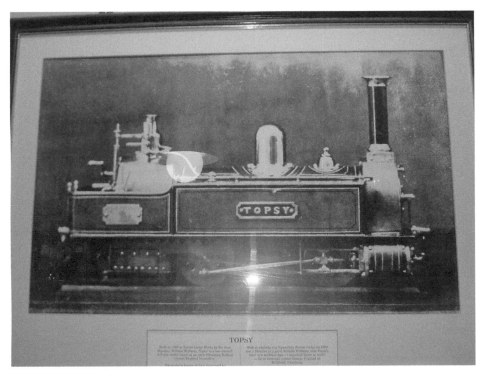

Miniature working steam locomotive *Topsy*.

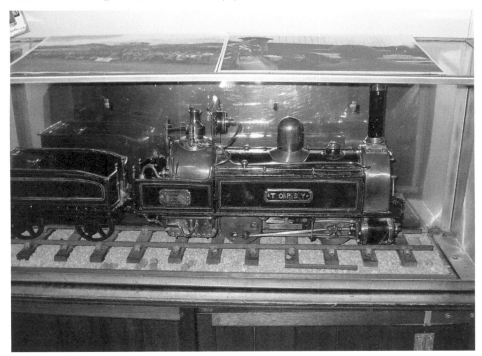

5 The Pontcysyllte Aqueduct, over the Dee

This is recognised as one of Thomas Telford's masterpieces. Tourists from all parts of the globe visit it daily. From Trevor and Froncysyllte they walk across it, adjacent to the canal, which carries narrowboats. In a new biography of Telford, author Anthony Burton describes this structure as 'the greatest achievement of the canal age. It was not just the height and length of the aqueduct itself, but immense embankments had to be built to keep the canal at a level as it strode across the valley, those at the southern end rising to above a hundred feet.'

Carrying the Llangollen Canal over the Dee, this 'stream in the sky' has eighteen arches, built of stone and cast iron. The piers are hollow above a height of 70 feet. It is the oldest and longest navigable aqueduct in the United

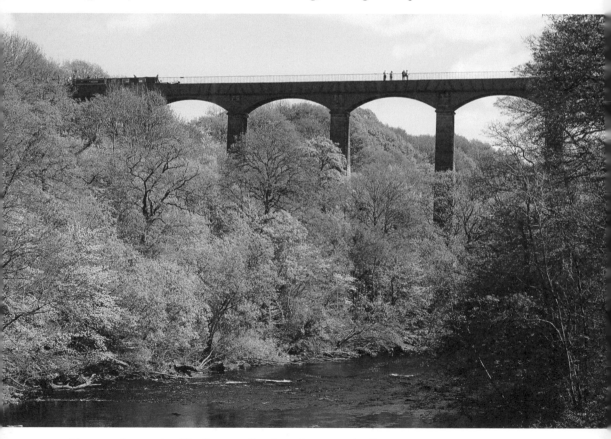

Above and opposite: The Pontcysyllte Aqueduct over the Dee.

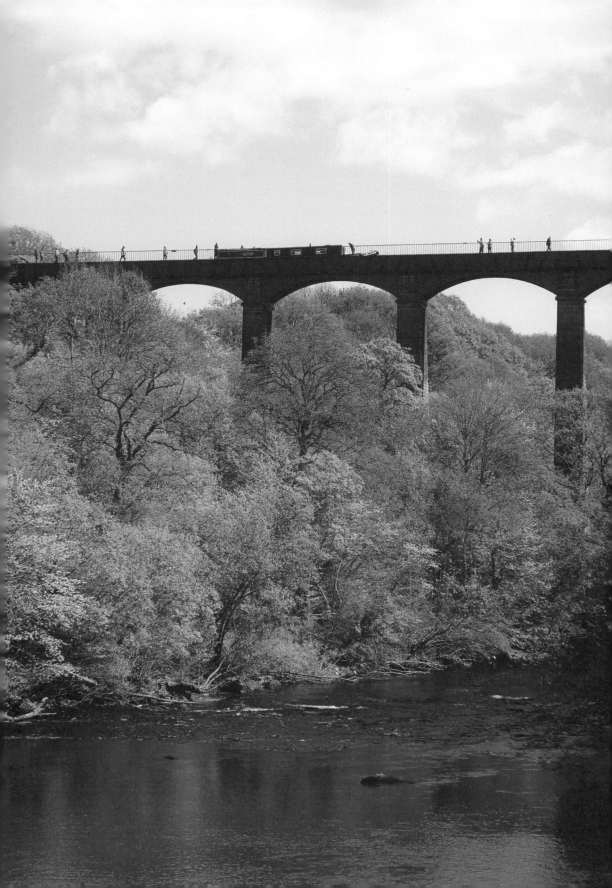

Kingdom, and the highest in the world. It has a length of 336 yards, a width of 4 yards and a height above the river of 127 feet. The trough was made of flanged plates of cast iron, bolted together, with the joint originally embedded with Welsh flannel.

It was originally intended to carry the Ellesmere Canal, making a commercial connection between the River Severn at Shrewsbury and the Port of Liverpool on the River Mersey, but this was never completed. Canal engineer William Jessop worked with Telford. Ironwork was supplied by William Hazeldine from his foundries at Shrewsbury and nearby Cefn Mawr. The original cost of the enterprise was around £47,000. It was opened in December 1805.

William Jessop was born in 1745 at Plymouth, the son of a foreman shipwright. By 1793 he had accepted the position of chief engineer and he became involved with some of the most demanding jobs in the eighteenth century. The Ellesmere Canal was very demanding. Proposals had been put forward to connect the rivers Severn, Dee and Mersey, reaching the coal and steel industries of North Wales. The canal rises steeply from the Cheshire Plain in a series of locks. Telford wrote in 1773,

> I was appointed Sole Agent, Engineer and Architect to the canal which is to join the Mersey, Dee and Severn. It is the greatest work, I believe, that is not in hand, in this kingdom, and will not be completed in many years to come. This is a great and glorious undertaking but the line which it opens is vast and noble ... and I thought it too great an opportunity to be neglected. Mr Pulteney approved much of it, as do all my friends, it will require great exertions but is worthy of them all, there is a very great Aqueduct over the Dee, besides Bridges over several rivers.

6 Rhuddlan Castle

A significant building on this site, close to a busy crossing of the River Clwyd, existed in the eleventh century. The Welsh leader Gruffydd ap Llywelyn had his palace here and in 1066 Harold Godwinson brought his men here and burned it. The family of the Earl of Chester established a house here. In the twelfth and thirteenth centuries, the fortress was captured many times by the Welsh. Henry III in 1241 had new buildings erected. In 1277 the present castle was complete, a contemporary of Edward I's castles at Builth, Aberystwyth and Flint. The chief designer was James of St George, and in the early fourteenth century Richard of Chester.

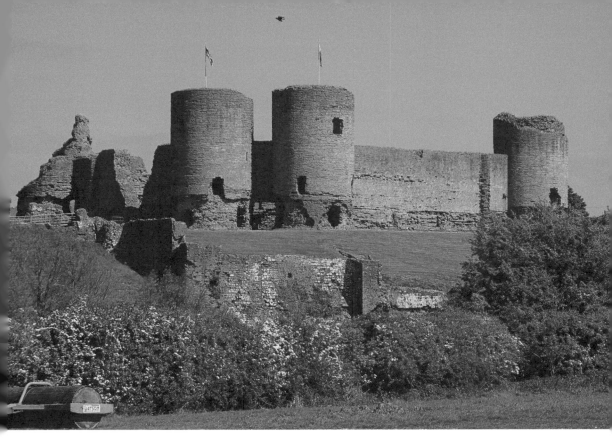

Above: The castle at Rhuddlan.

Below: Interior of Rhuddlan Castle. (Courtesy of Steve p2008 under Creative Commons 2.0)

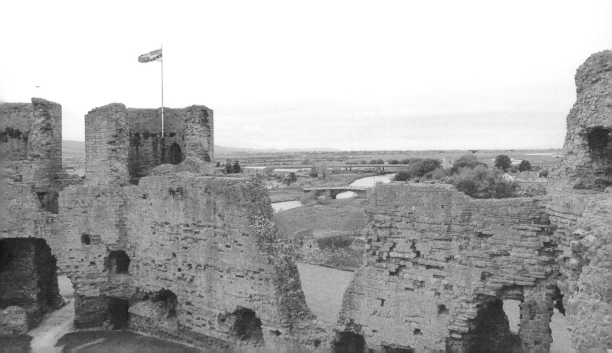

The plan is concentric, with a moat on three sides. There are circular towers and double-towered gatehouses. Its regularity of plan was unusual in English medieval architecture.

In 1277, Edward I started a new stone castle where Llywelyn ap Gruffydd submitted to the English king. The designer James of St George had the castle completed and in 1282 the Welsh attacked it. Edward I and Eleanor stayed at Rhuddlan in 1278. A new town was created to the north, with English residents enticed by low rents. The lower course of the Clwyd was straightened so that ships could enter and land at the new quay below the parish church.

Owain Glyndwr and his men attacked the town in 1400 but the castle was not taken. In the fifteenth and sixteenth centuries, the castle lay in neglect but was held for Charles I in the Civil War. In 1646, the castle was surrendered to General Thomas Mytton. In 1944, the Conwy family, who had been constables of the castle since the early fifteenth century, handed the motte-and-bailey castle over to the State for preservation.

7 The Quay at Conwy Town

Conwy is the name for the town, the river and the county. The town is dominated by the ancient castle: 'Conwy [castle] is one of the great achievements of medieval military architecture in Europe' (Simon Jenkins).

Before Conwy Town was created, the site was occupied by a Cistertian monastery. From 1070, the kings of England and the Welsh princes fought over this territory, which was an important crossing point on the river, overlooked by Deganwy Castle.

The great artist Turner was here, painting the castle, in 1798. He wrote of 'sublime and overwhelming emotion' when seeing the estuary, harbour and castle.

The quay was an important feature of the supply of men and goods to the town and castle. It has the Liverpool Arms adjacent and also the Smallest House. Mussel gathering has been present here for centuries, the mussel beds located half-a-mile downstream, gathered by rakes from small boats. They are processed at the centre at the quayside, the impurities removed by a thorough washing method. Conwy mussels are meatier and larger than usual and have a distinctive flavour. The baskets in the picture are used for lobster and crab fishing, and Conwy lobsters are found in nearby restaurants.

A. G. Bradley writes,

you may at any time see all sorts of quaint and humble craft, even up to 500 tons, with sails of various hues, and hulls of many shapes and colours,

The Conwy Estuary from the Conwy Quayside.

working their way in or out, or lying in the river ... the mussel catchers, a leading feature here in local life, patiently clawing at the river bottom with their long-handled rakes, from the bows of their boats as they anchor in mid-channel, a long and noiseless procession. They have been at this business – as a community I mean – ever since time was ... the receding tide leaves mussels high and dry upon the rocks, to be had for the picking. Once upon a time the women made more out of the pearls found in the shells than it is now possible to do out of the fish – a great deal more. For Conwy pearls were, in former days, quite an item in local trade. The great ladies of North wales in the 16th and 17th centuries were proud to wear them on their necks and arms. The old Welsh regalia contained some, and among the Crown Jewels of the Tower there are one or two specimens. But the demand for mussels nowadays in Liverpool and elsewhere leaves but little opportunity for the slow development of the pearl. (*Highways & Byways in North Wales* (Macmillan, 1898))

The marina is busy with small sailing boats with many moorings. The estuary of the River Conwy is wide and tidal, with Deganwy in the background. Llandudno is beyond. Aberconwy House in the high street is a valuable survivor from medieval times.

William Condry writes,

the northern tip of the Park [Snowdonia National] at Carhun ... where the Romans placed an important stronghold to guard the tidal waters of the Conway River ... sunshine, a mild climate and shelter from most winds. They could get trout, salmon and shellfish from the estuary; and, like the British before them, they got pearls from Conway mussels. Probably at that time the migrating salmon and sewin were encircled by nets paid out from small boats just as it is done today and just as it had been done for ages before the Romans.

8 The Seaside at Llandudno

Llandudno's shoreline is 2 miles long, situated between the headlands Great Orme and Little Orme. It sits on the Creuddyn Peninsula facing the Irish Sea. The town's name is derived from its patron saint, St Tudno.

Simon Jenkins writes, 'A noble legacy was offered by the Mostyns of North Wales, who laid out Llandudno as a graceful resort with an aspect that the

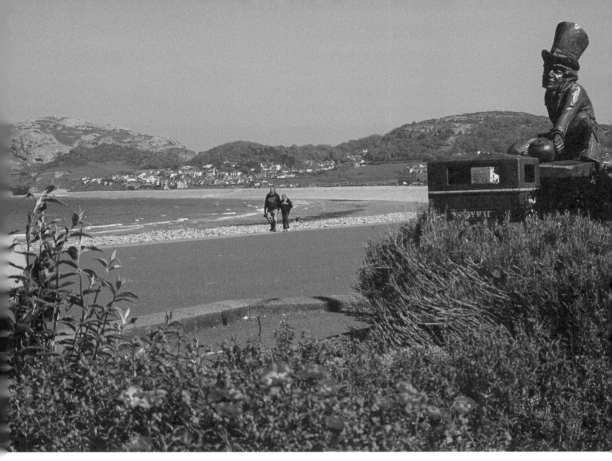

Llandudno seaside.

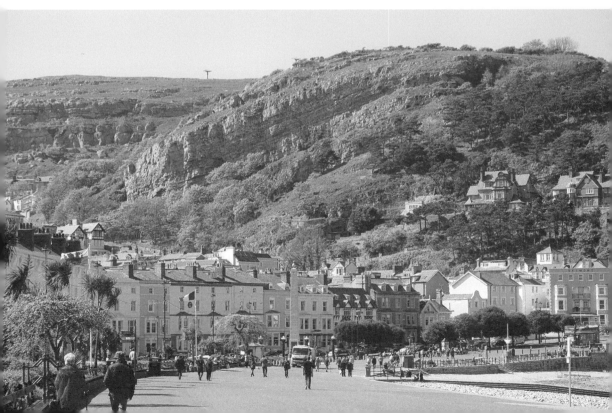

Victorians boasted was worthy of the Bay of Naples' (*Wales: Churches, Houses, Castles* (Allen Lane, 2008)).

The description 'Queen of the Welsh resorts' dates back to 1864, not long after the resort was planned. It is linked with the communities Penrhyn Bay and Penrynside. The limestone headland, Great Orme, has Stone Age, Bronze Age and Iron Age history. The town's origins are at the Manor of Gogarth in the time of Edward I. The Great Orme is known for its wild Kashmiri goats, which stem from a gift of goats made to Lord Mostyn, the land owner, by Queen Victoria. The height of this headland is 679 feet. At its peak is The Summit Hotel, once owned by boxer Randolph Turpin. There is a range of flora and fauna including a species of wild cotoneaster, only to be found here. A wide variety of sea birds nest in the cliffs. There is a Great Orme tramway and a cable car carrying visitors to the summit.

The local Church of St George was built in 1840. The population then mostly worked in the copper mines on the Orme. Llandudno as a holiday resort started in 1848 when Owen Williams, an architect, presented Lord Mostyn with plans for development. The Mostyn estate took the plans forward, and still own the land. Between 1857 and 1877 the present façades and street scene were planned and built under the supervision of George Felton, who designed Holy Trinity Church in Mostyn Street. The pier was built in 1884. It is a Grade II-listed building and is the longest pier in Wales at 2,295 feet. The Happy Valley, a former quarry, was a gift of Lord Mostyn to the town in celebration of Queen Vistoria's Golden Jubilee of 1887. The single-stage cabin lift is the longest in Britain; it travels over one mile to the summit.

The *Mad Hatter* statue was designed and created in oak by Simon Hedger. It celebrates the town's link with author Lewis Carroll, author of *Alice in Wonderland*. The family of the 'real Alice' (Alice Liddell) regularly spent holidays in the own at their holiday home Penmorfa, later the Gogarth Abbey Hotel. There is a story that the author wrote parts of the book while staying at the St George's Hotel.

9 Bangor-on-Dee Racecourse

Located in the old district of the Hundred of Maelor, originated in 1282, of some 46 square miles to the east and south of Wrexham, Bangor occupies an attractive position on the Dee. Maelor Saesneg, or English Maelor, shares common boundaries with Shropshire, Cheshire and Wrexham County Borough. In the period 1100–1282 Maelor was part of the Welsh principality of Powys Fadog.

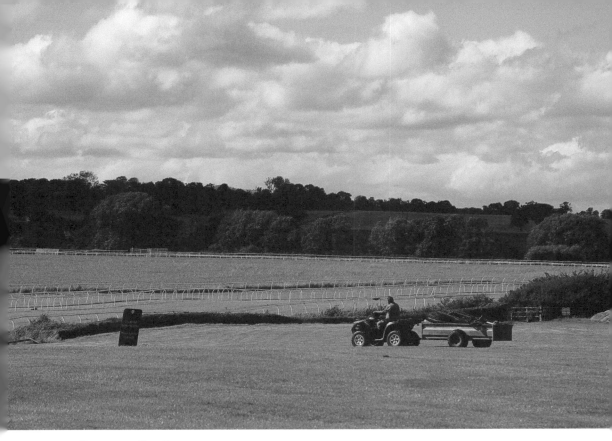

Bangor-on-Dee Racecourse.

This racecourse was the only one in Wales when the one in Monmouthshire was not considered to be located in Wales. It dates back to 1850 when the Hon. Lloyd Kenyon of Gredington and Richard Myddleton Biddulph of Chirk Castle had a race there to settle a wager. This attracted a large crowd of spectators and it was decided to make it an annual event, with members of the Sir Watkin Williams-Wynn's Hunt and local farmers competing.

This course became a regular feature in the National Hunt calendar, with regular events during the season. In 1981 there were eight National Hunt races over roughly the same course as the first event, on pleasant farmland in a huge loop of the River Dee.

There is no grandstand but rising ground affords a good view of the racing. There can be over 15,000 spectators on a good day. It has the atmosphere of a rural event. In 1868 a boy named Richard Archer rode his horse to victory in a ponies under 14 hands even; he became a famous jockey.

The town Bangor-is y-Coed was the location in the sixth century of a large Celtic monastery, said to have 2,000 monks. In the massacre during the Battle of Chester in 1615, 1,200 of them were put to death (according to Bede) by Ethelfrith, King of Northumbria. The exact site of the monastery is not known.

The church, which is dedicated to St Dunawd, is distinguished. The architect Douglas made restorations here in the late nineteenth century, and was married here in 1860.

The Bangor Bridge dates from 1658, with its five unequal elliptical arches. Near the racecourse is Althrey Hall, an early sixteenth-century, two-storey, timber-framed, gabled mansion. It was occupied by the Powell, Ellis, Whitley and Plymouth families. It contains a secret recusants' chapel. In 1987 a wall painting dating from around 1530 was discovered.

Until the building of flood-control sluices at Bala Lake and the strengthening of the embankments at Bangor in the 1950s, melting snows and torrential rains in the Welsh mountains regularly caused the River Dee to overflow its banks between Erbistock and Farndon. Coracles were used in the early days for fishing on the Dee in the Erbistock/Bangor area.

Iscoyd Park was a country mansion, the seat of P. W. Godsal in 1895. The Iscoyd estate was purchased in 1739 by William Hanmer. Von Ribbentrop, Hitler's foreign minister, stayed at the hall for Chester Races in 1938, as a guest of the then tenant Sir John Reynolds.

10 The Telford Suspension Bridge, Conwy

Anthony Burton, in his biography of Thomas Telford, writes,

> In other circumstances, the Conwy bridge would have been a marvel, and was undeniably a great boon. Once again, a dangerous ferry crossing was replaced by a safe, smooth ride on a well-maintained roadway. There were no dramas during construction, and even the setting of the chains in place seemed a routine matter after Menai. Telford did not even turn up in person, and he heard the news by letter. 'Have pleasure to inform you that the first chain was taken over at Conwy Bridge yesterday' [Thomas Rhodes to Telford, Dec 1825].

At opening day, there were great celebrations. The *Chester Mail* said the site was packed: 'the people shouting and screaming … the horses went steadily over … the passengers singing "God Save the King" as loud as they could … Most of the carriages of the neighbouring gentry, Stage Coaches, Post Chaises, gigs and horse passed

Below and overleaf: Telford Suspension Bridge, Conwy.

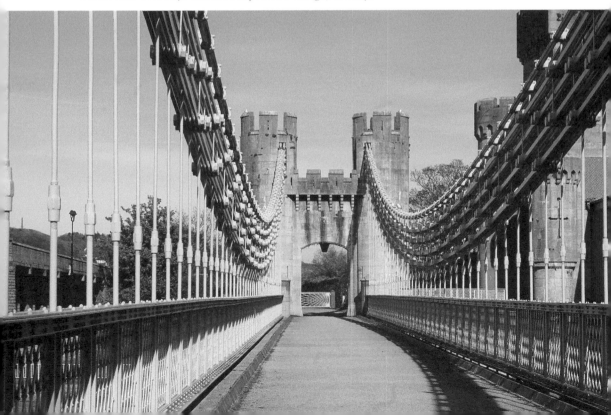

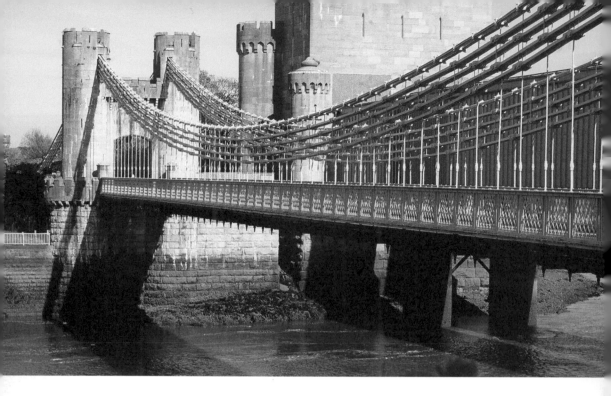

repeatedly over ... everyone seemed satisfied with the safety of the bridge' (William Provis, July 1826). The bridge originally carried road traffic from Chester to Bangor.

There are three bridges now crossing the River Conwy here: the road bridge built in 1958, the Suspension Bridge, and the railway crossing. The Suspension Bridge is a Grade I-listed structure and was one of the first suspension bridges in the world.

Telford's design added castellations to the towers and added a miniature castle to match the greater one adjacent (a World Heritage Site). The bridge is only a part of the structure over the River Conwy, with an embankment over 2,000 feet long, 300 feet wide at the base.

The original wooden deck was replaced by an iron one in the late nineteenth century, and when the new road bridge was built, this suspension bridge was open only to pedestrian traffic. It is owned by the National Trust.

11 Mount Tryfan

Tryfan is one of the major mountains of North Wales, located between Capel Curig and Bethesda, a few miles from Llyn (Lake) Ogwen, within the Snowdonia National Park. It is a favourite with climbers and walkers. Its name is derived from the Welsh word for three, 'tri', standing for its three peaks. It is part of the Glyder group of mountains. Its peak is 3,010 feet above sea level and has been voted Britain's favourite mountain.

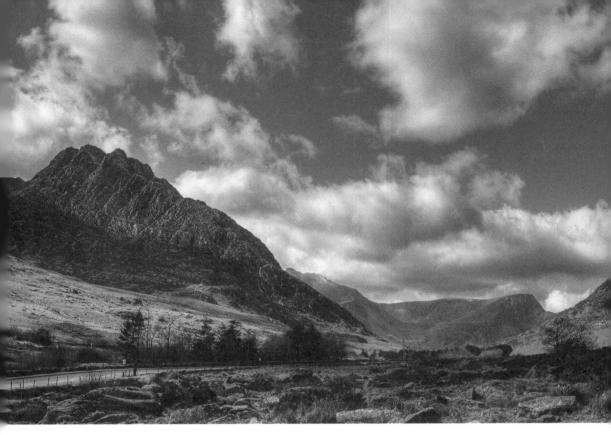

Tryfan from the A5 Nant y Benglog.

Its north ridge can be traversed by starting from near the A5, close to Idwal Cottage (a youth hostel) or Ogwen Cottage (outdoor pursuits centre) – a Grade I scramble leads directly to the ridge. There is a distinctive rock known as 'The Cannon' that points upwards and is visible from the valley. The usual mountaineering precautions must be taken.

The summit of Tryfan features the monoliths Adam and Eve, a pair of rocks some 3 metres high, separated by 1.2 metres. These are visible from the Ogwen Valley. It is said that those who step from one rock to another gain the 'Freedom of Tryfan'. However, the author Showell Styles wrote, 'In calm dry weather it is not too hard a step but the penalties of failure are unpleasant in the extreme.'

Milestone Buttress at the base of Tryfan is a location for rock climbing. It can be accessed from a roadside layby. It is over 200 feet long and graded 'very difficult'. It was first climbed in 1910.

Wild goats are sometimes seen here. In 1775, Dr Samuel Johnson wrote from Llanberis that Miss Thrale, the daughter of his companion Hesther Thrale, had counted 149 goats on the slopes of Snowdon. William Condry writes, 'Some magnificent goats, wild and ibex-like with their towering, swept-back horns, still thrive on the rocks of Tryfan.'

This remarkable atmospheric photograph, by Tom Gregg, was taken from near the major artery road, the A5, in Nant Benglog, after traversing the the Nant Ffrancon Pass in the Capel Curig direction.

12 The Trevor Basin for Narrowboats

The village of Trevor is halfway between Wrexham and Llangollen. The Trevor Wharf carries the Llangollen Canal, which joins the Shropshire Union Canal. This links with canals and waterways that stretch through western Britain. The departure bases for narrowboats, with eleven locations, cover from Bunbury in the north to Bradford-upon-Avon in the south. The Anglo-Welsh company have been in business here over for forty years, owning 160 narrowboats, some with two berths and many with more. The boats are hired to visitors who enjoy the slow trip through countryside.

The Telford Inn, next to the canal, was created early in the nineteenth century to house workers from Scotland who came down to build the Pontcysyllte Aqueduct.

Trevor Hall, from the eighteenth century, looks out across the Vale of Llangollen. The house was bought by the Ruabon brick and terracotta manufacturer J. C. Edwards, of PenyBont Works, Cefn Mawr. The Lloyds of Trevor Hall built a private chapel where the church stands in the early eighteenth century.

The house Plas-yn-y-Pentre, dated 1634, is located between the canal and the River Dee. Bryn Howel, on the A539, was built in 1896 by J. C. Edwards, son of

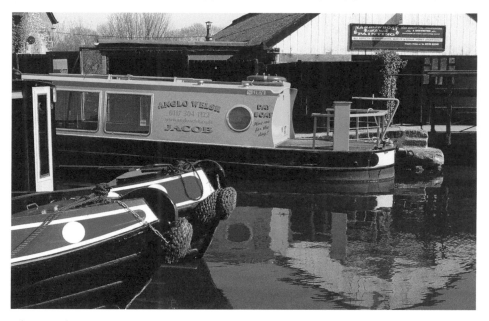

Above and opposite: Narrowboats at Trevor.

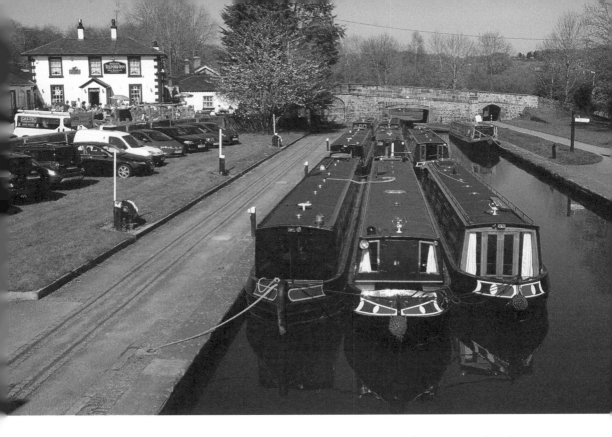

the above, who also ran a brick-making business. His products are evident here – bright red brickwork, terracotta, tile hanging and a tiled roof.

There are Telford canal bridges at Bryn Howel and beside the main road at Trevor Uchaf.

13 Minera and Lead Mining

The Latin name is appropriate in an area that has yielded its mineral wealth for various uses since Roman times. Lead, coal, limestone and silica have been extracted on a large scale. The waste from lead mining can be toxic, and workers here frequently had serious health problems. Lead here was mined over centuries, leaving a honeycomb of shafts, tunnels and levels. More than a hundred shafts survive, the deepest being 1,360 feet. New Brighton was the location of smelting works. Nearby is Esclusham Mountain, leading for walkers to World's End in the Llangollen vicinity.

Amid scarred landscapes, south of New Brighton, is the engine house of the Meadow, or City, shaft of the Minera Lead Mine, from the mid-nineteenth century. It is ruinous with a separate chimney.

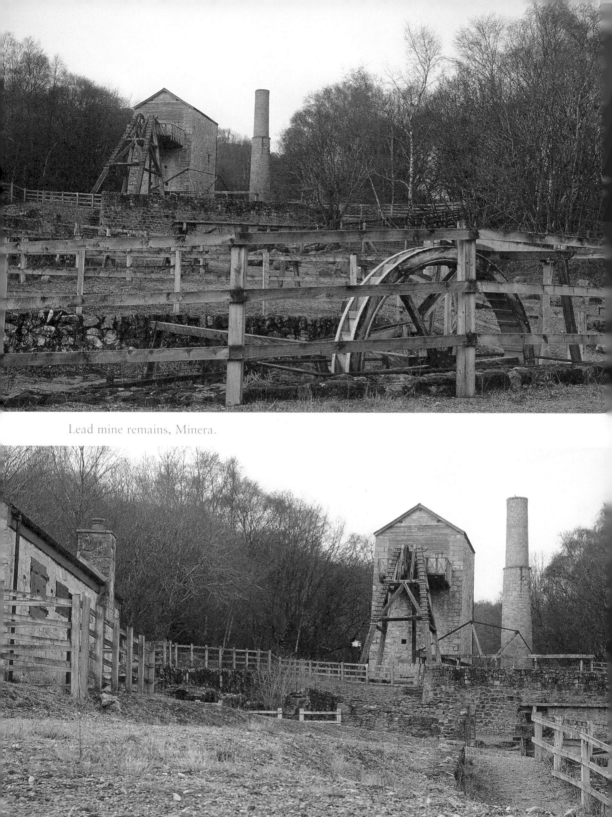

Lead mine remains, Minera.

14 Bersham Colliery

It was here that the great ironmaster John Wilkinson developed his iron-making techniques, which gave Bersham a significant role in the Industrial Revolution. The Wilkinsons, a Cumbrian family, took over at Bersham in 1753 and by 1762 John Wilkinson was producing pipes, shells, grenades and guns. By 1775 he was boring cylinders for James Watts' famous steam engines, which were to give a new impetus to industry in Britain. Most of the canons for the Peninsula War, the Russo-Turkish Wars and the Napoleonic Wars were supplied from Bersham. The name of a row of cottages, Bunkers Hill, recalls Bersham's role as armaments supplier to the American War of Independence. Wilkinson switched his interest in iron making to Brymbo.

At its peak, there were thirty-eight colliers in the Wrexham district. They supplied Brymbo Steel Works and the Shotton Steel Works. The first shaft at Bersham was sunk in 1864. In 1874, there were two shafts, with depths of 420 and 421 yards. They were among the deepest mines in Europe. In the twentieth century, the communities of Rhostyllen, Rhosllanerchrugog and Johnstown grew in association with the coal mines (including Hafod, which was next to Bersham) and sons followed their fathers to work in the mines.

In 1923, Bersham employed 908 men. Nationalisaton of the British coal industry came in 1947, under the National Coal Board. Bersham was improved

Below and overleaf: Bersham Colliery remains.

in 1954 with new machinery, pit baths, canteen and offices. The 100 pit ponies at Bersham, having been underground for most of their lives, were retired. The colliery reached its largest size in 1958, with 1,011 men employed.

The nearby Erddig Hall suffered subsidence of around 5 feet, caused by mining underneath, and the Coal Board paid compensation of £120,000 to stabilise the building.

Bersham Colliery was closed in 1986 suffering the loss of 480 jobs. The nearby communities were heavily hit by unemployment.

15 St Asaph Cathedral

This Anglican church is the episcopal seat of the Bishop of St Asaph. The cathedral dates from 1143, while the current building dates from the thirteenth century. The tower was added in 1391 by Chester mason Robert Fagan.

The present building is cruciform, with a central tower, aisled and clerestories nave. With a length of only 182 feet it is the smallest in Wales and England. Dr Jonson noted that 'it has something of dignity and grandeur'.

The first church here was in the time of St Kentigern (St Mungo) in the sixth century, who was forced to leave his see at Glasgow. In 1143 the church was refounded as part of the Norman reorganization of the Welsh Church. In 1282,

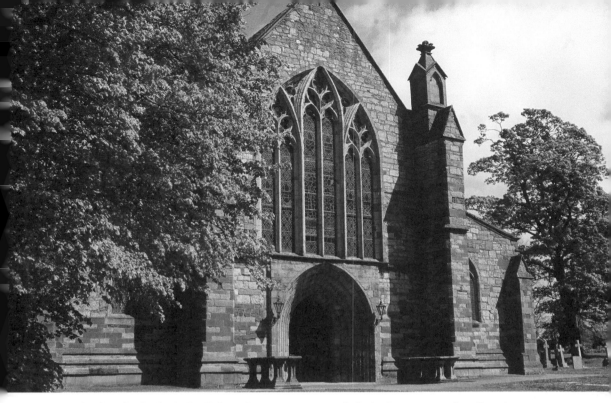

St Asaph Cathedral. (Below image courtesy of Jack Langton under Creative Commons 2.0)

the first building was burned down by Edward I. The rebellion of Owain Glyndwr caused attacks on English buildings and the Anglican church. The Welsh monarch Henry Tudor, later Henry VII, put up the present building, which was greatly restored in the nineteenth century. In 1930, the tower was subject to subsidence and repairs were undertaken. In 1867–75 much restoration and alteration work was done by Sir Gilbert Scott.

William Morgan (1545–1604), the son of a peasant farmer from near Betws-y-Coed, was Bishop of St Asaph and Llandaff. He translated the whole of the Bible from Aramaic, Greek and Hebrew into Welsh, the greatest intellectual task ever completed in Wales. His bible is kept on public display in the cathedral.

In the north transept is the 'translators' chapel', marking the translators of the Bible into Welsh in the sixteenth century.

In the churchyard is the Translators' Memorial, commemorating the tercentenary of Bishop William Morgan's Welsh Bible of 1588. There are statues of his precursors and collaborators in the translating of the scriptures into Welsh.

An impressive painted cloth depicting the Tree of Life, by a Haitian artist, hangs in the south transept.

16 Henry Morton Stanley of Denbigh

A major figure from the Wales hinterland, Henry was born in Denbigh in 1841, in a cottage by the walls of the castle. His mother was eighteen; his father not known; and he was brought up by his maternal grandfather, Moses Parry, a once-prosperous butcher. His birth certificate describes him as a bastard. At the age of five, after staying with relatives, he was sent to the St Asaph Union Workhouse for the Poor, where he had a bad time. When he was ten, his mother and two half-siblings stayed there, but neither recognised one another.

A. C. Bradley, in his *Highways and Byways in North Wales* (MacMillan, 1898) writes: 'Within a stone's throw – within the castle walls, in fact, and upon ground where a tennis court is now paid out, stood the cottage where H. W. Stanley, the great explorer, was born.'

At the age of 18 he emigrated to the USA, disembarking in New Orleans. Here he took the name of Stanley from a wealthy trader. Stanley's *Autobiography* is colourful and not always truthful, but he was a good writer.

He enrolled in the Confederate Army during the Civil War; he was in the 6th Arkansas Infantry Regiment and fought in the Battle of Shiloh in 1862. After being taken prisoner, he was recruited into the Union army, but because of an illness he was discharged. He then served on merchant ships before joining the US Navy in July, 1864. He became a record keeper on the *USS Minnesota*, and from then on he became a writer. He jumped ship in Portsmouth, New Hampshire. He was possibly the only man to have served both sides during the Civil War and in the Union Navy.

The west of the USA was an expanding frontier and Stanley wrote about it. In 1867 he became a special correspondent for the *New York Herald*; he was the first to report the fall of Magdala in 1868.

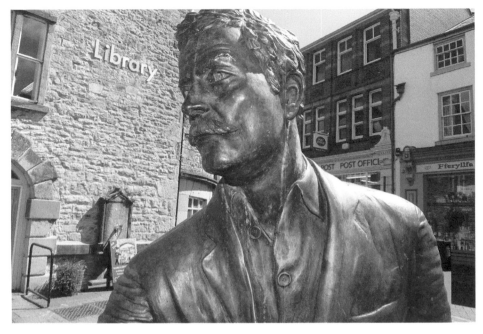

Statue to Henry Morton
Stanley, Denbigh.

Dr David Livingstone had left for Africa in 1866 to search for the source of the Nile. Stanley arranged an expedition, travelling to Zanzibar in 1871. He endured a 700 mile trip through tropical jungle, finding Livingstone near Lake Tanganyika. His line 'Dr Livingstone, I presume' was probably invented later in order to add colour to his story. He wrote a book about his adventures, denying the details of the 'discovery' of Dr Livingstone.

He made other trips in Africa, making long and dangerous traverses. He was physically a very strong man and he had great presence. He was undoubtedly a man of significance in geography, establishing many land and river identifications. Stanley worked for King Leopold in the Congo. His book *Through the Dark Continent* was published in 1878.

By 1890 Stanley was back in Europe, becoming, after his marriage, an MP for South London. He was knighted in 1899, receiving a Knight's Grand Cross of the Order of the Bath. He died in London in 1904.

The impressive statue in his memory, placed in 2011 on the patio in front of the library at Vale Street, Denbigh, was sculpted by Nick Elphick of Llandudno.

17 The Marble Church of Bodelwyddan

(One of Simon Jenkns's Top Thirty Building's of Wales)

It is called the 'marble church' because of the thirteen different kinds of marble used to create its ornate interior. Another distinguishing feature is its spire, which is visible from many miles away because it rises to 202 feet. It is in the Vale of Clwyd, close to Abergele.

The building was originally commissioned by the daughter of Sir John Williams, of nearby Bodelwyddan Castle – Lady Margaret Willoughby de Broke. Her husband, to whom the church was dedicated, was Henry Peyton-Verley, 16th Baron Willoughby de Broke. The church was designed by John Gibson, a Warwickshire architect, who had studied under Sir Charles Barry, architect of the Palace of Westminster, the home of the UK Parliament in central London.

It was built in 1856–60 and consecrated in the latter year by the Bishop of St Asaph. The construction cost £60,000.

Inside, there are pillars of Belgium red marble, and a nave entrance is of Anglesey, Languedoc and Purbeck marble. The marble was imported from Belgium, Italy, France, Ireland, England and Wales. The main building is of

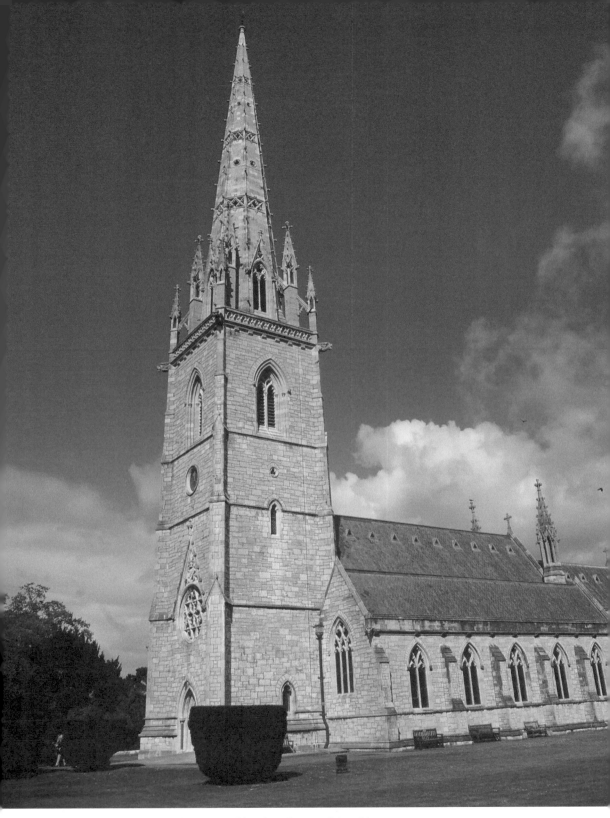

Above and overleaf: The Marble Church at Bodelwyddan.

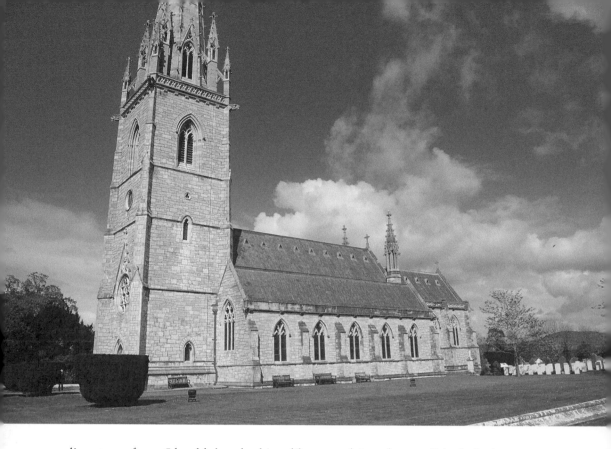

limestone from Llanddulas, looking like porcelain when polished. In honour of St Kentigern, granite from Aberdeen was used to create niches by the main entrance. Inside there is elaborate woodwork. In the tower there are stained-glass windows to the north and south sides, showing St Margaret and St Kentigern.

In the churchyard is the grave of Elizabeth Jones, mother of Sir Henry Morton Stanley, the explorer and author. Also there are eighty graves of Canadian soldiers stationed here in the First World War. They were in Kinmel Camp, in the grounds of Kinmel Hall. The flu pandemic of 1918–19 took many lives. Five Canadian soldiers were killed here when a riot happened because the Canadian ship that was to carry the men home was diverted to take food to Russia.

18 The Pontcysyllte Aqueduct

Edward Hubbard, in his great book *Clwyd* in the Buildings of Wales Series, writes, 'Carrying a canal 127 feet above the waters of the Dee, it earned the nickname "the stream in the sky", and deserves its reputation as an engineering achievement of consummate mastery.'

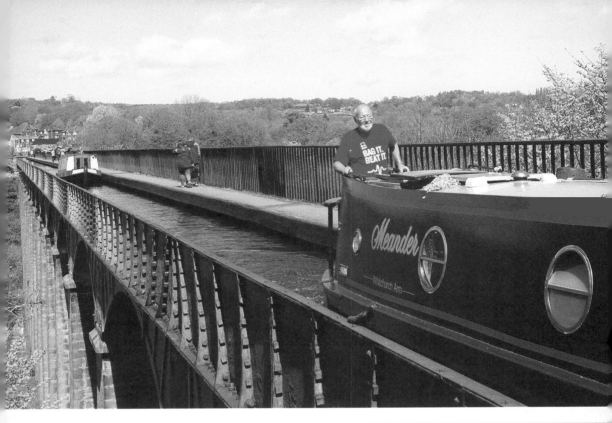

Above: The aqueduct at Froncysyllte.

Right: Edge of Pontcysyllte Aqueduct. (Courtesy of Marek Isalski under Creative Commons 2.0)

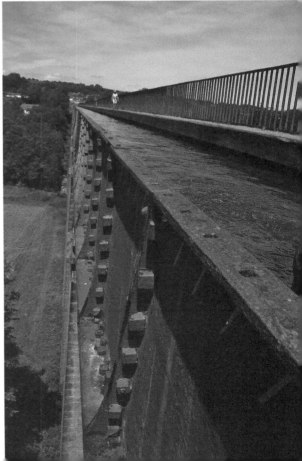

The original intention was to link Liverpool with Chester and Shrewsbury by canal, but the scheme was never finalised. However, the scheme at Trevor/Froncysyllte was approved. The Ellesmere Canal came under the management of William Jessop and in 1793 Thomas Telford became 'General Agent, Surveyor, Architect and Overseer of the Works'. Building of the aqueduct began in 1795. It was a full-height structure, to maintain the level of the canal, with a cast-iron trough on stone piers. Completed in 1805, there were nineteen bays, each with a 45-foot span, with four iron arches carrying the trough. The piers are solid up to a height of 70 feet, then become hollow, with internal cross-buttressing. The length of the rough is 1,007 feet. A towpath is supported by framing within the trough. There is protective railing on the towpath side only, making the experience of crossing by boat 'exhilarating and vertiginous' (Hubbard).

The joints between the iron plates were originally Welsh flannel soaked in white lead; later this was replaced by tar. The ironwork was created at the local Plas Kynaston ironworks under the ownership of William Hazeldine – Telford wrote describing him as 'the arch conjuror Merlin Hazeldine'.

The opening of the Pontcysyllte Aqueduct was on 26 November 1805. Guns were fired by the Shropshire Volunteers, who played airs with their band. It is said that 8,000 people turned up. A printed card was handed around that cited Telford as 'The Engineer', John Simpson the contractor, Hazeldine for the ironwork, Davidson as superintendent and William Davies for the earthworks. A speech made at the time praised Telford who 'with the advice and judgement of our eminent and much respected Engineer, Mr Jessop, invented, and with unabated diligence carried the whole into execution'.

Anthony Burton concludes, 'it remains a spectacular tribute to the imagination and skill of all who were involved in its construction.'

19 The Llangollen Canal

The road from Llangollen towards the English border takes you towards Chirk and Oswestry. Travelling this road takes you along the edge of the Dee Valley. Over to the left is the extended village of Cefn Mawr, next to Newbridge (suitably named). A small turning to the left in Froncysyllte (translated as 'the edge of the joining-place) take the driver to a car park, which is next to a widening place of the Llangollen Canal where narrowboats halt and turn. Toward the aqueduct, which is a good walk, boats are moored, sometimes including families who exercise their dogs along the path. The canal is wide and full, overhung with trees. Narrowboats come towards you, their engines throbbing their colours outstanding. They can make their way towards Llangollen where the channel

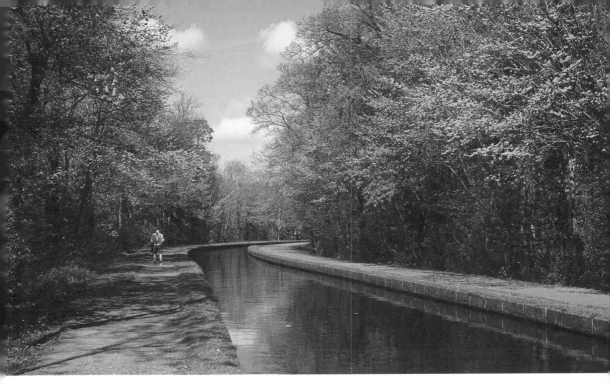

The Llangollen Canal.

narrows as it flows above the road, with boats in the summer full of visitors, drawn by faithful horses.

The Llangollen Canal was completed in 1808, constructed as a navigable feeder for the Ellesmere system. Its water is drawn from the Dee at the Horseshoe Falls, a crescent-shaped weir designed, with the canal, by Telford.

20 Valle Crucis Abbey, Llangollen

Situated in a grand place, just below the Horseshoe Pass where there is plenty of fresh water, Valle Crucis Abbey is partly standing, reminding one of Tintern Abbey. It sits, unfortunately for viewing from above, immediately next to a caravan park.

It was founded as a Cistertian monastic house in 1201 as a colony of Strata Mercella. It has a cruciform plan with pairs of chapels in each transept and an aisled nave of five bays. There was a fire here, and the abbey was rebuilt. The west doorway is enriched and heavily moulded. Stone carved details are evident, including leaf capitals. The west window of Valle Crucis dates to the late thirteenth century, with decoration. Within three centuries much was added and rebuilt.

There are sepulchral slabs celebrating twelfth- and thirteenth-century characters, including a shield and sword, one to Madog ap Gruffydd Maelor (d.1236), the founder of the abbey.

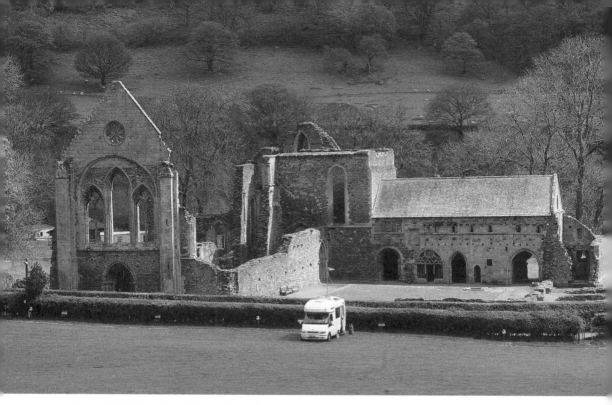

Above: Valle Crucis Abbey, Llangollen.

Below: Interior view of Valle Crucis Abbey. (Courtesy of Steve p2008 under Creative Commons 2.0)

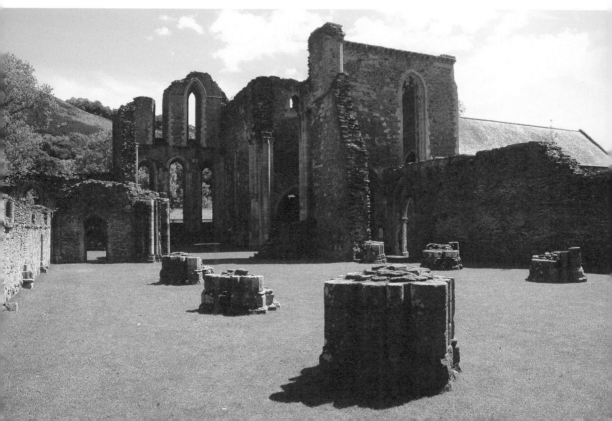

Simon Jenkins notes that 'Valle Crucis lapsed from strict Cistercian rule, and poets such as Iolo Goch and Gutyn Owain related the sumptuous hospitality to be had at its table before the Dissolution. One feast reputedly included a thousand apples and gifts to guests of swords and bucklers.' (*Wales: Churches, Houses, Castles*, Allen Lane, 2008)

21 The Dee at Llangollen

This small town has received visitors for centuries. It was the home of the celebrated Ladies of Llangollen and since 1947 it has welcomed the International Eisteddfod, with musicians and dancers coming from all parts of the world for a week of music and celebration.

The River Dee runs through the town in a cascade of flowing water and rills divided by stones. The Church of St Collen sits over the river, with its tower from the mid-eighteenth century. Its churchyard contains a triangular Gothic tombstone in memory of the ladies and their housekeeper, erected after her death in 1809. The church is from the fourteenth century, with many embellishments during the Victorian era.

The Dee is the principal river of North East Wales. It is 70 miles long, coming to its end as it flows through Chester and, passing Connah's Quay and Flint, forming the western edge of the Wirral peninsula, then joining the Irish Sea. Its source is deep in Snowdonia, above Llanuwchllyn, then flowing down to Bala Lake towards Corwen.

William Condry writes, 'From Dduallt you have the Caernarvonshire and Merioneth mountains all around you in one uninterrupted circle. Immediately below you on to the east a widely stretching cotton-grass moor rises to a slightly domed watershed marked by deeply eroded peat hags whose channels are scattered with the remains of prehistoric birch trees. Three streams flow south from this watershed, three rills through the heather that quickly unite and become the River Dee, which wanders a mile or so through quaggy ground in a hesitating, southward way before, with a sudden resolve, it runs east for Bala Lake.' (There can seldom be a better account of the birth of a great river.)

The mature Dee approaches Llangollen rapidly, passing under the historic chain bridge, originally built in 1814 but later restored. The river enters the Vale of Llangollen and flows under the town bridge, of sixteenth-century origin, which is Grade I listed. In the vale, it passes under the high Castell Dinas Bran, a ruin dating back to medieval times.

In the days of the Celtic chieftains, the Dee was considered a sacred river, its various paths signalling significant changes in the fortunes of the tribes.

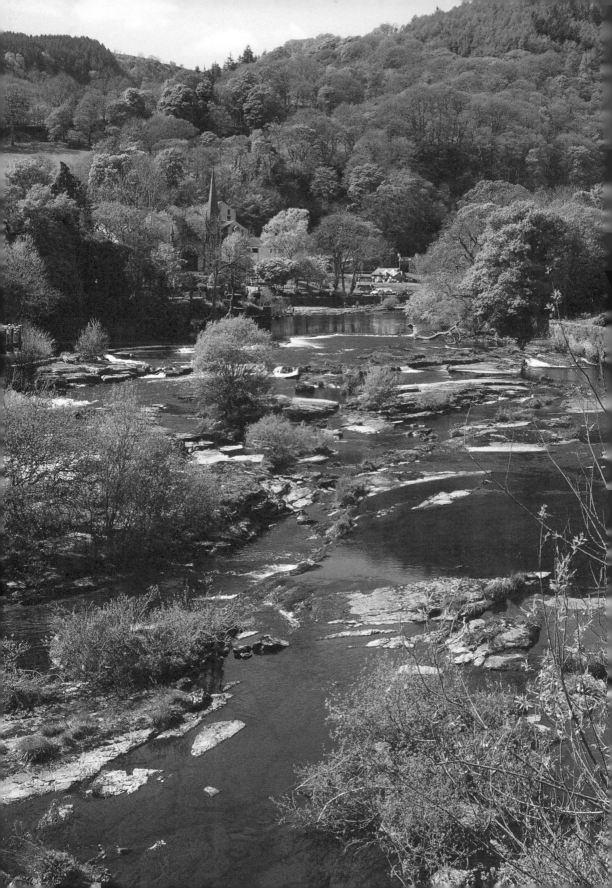

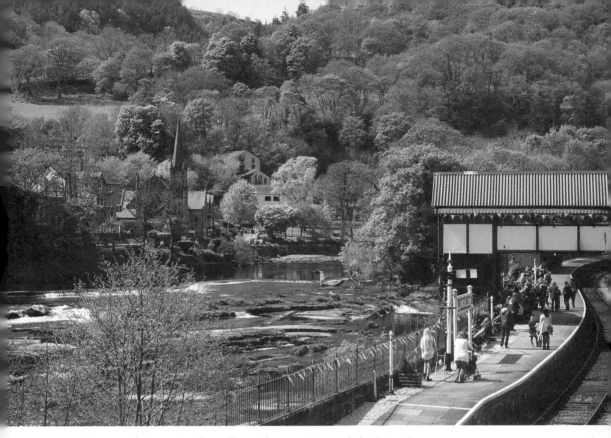

Above and opposite: Llangollen railway station and the River Dee.

22 The Grave of Elihu Yale

East of the tower of St Giles' Church, the tomb of Elihu Yale marks one of the area's leading figures. Son of a local family, he went to India to work for the East India Company, becoming Governor of Madras – he made a lot of money. He came back to live in Wrexham, spending some time in London. He lived at Plas Grono, at the outskirts of Erddig. He made a benefaction of books, artefacts and money to New Haven educationalists, which led to the founding of Yale University, named after him.

He also presented gifts to Wrexham Parish Church including a painting in the ante-nave. He died in 1791. The inscription on his grave reads:

> Born in America, in Europe bred,
> In Africa travell'd, and in Asia wed,
> Where long he lov'd and thriv'd;
> At London dead.

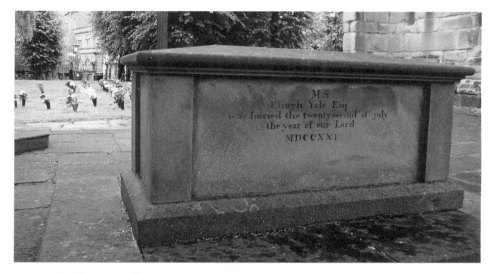

Grave of Elihu (*sic*) Yale, Wrexham Church.

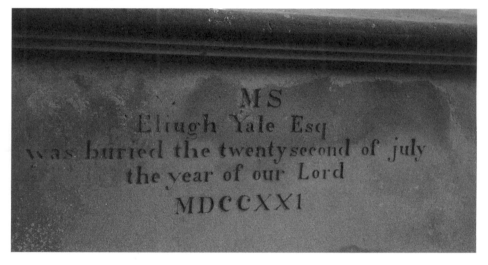

23 Church Gates, Wrexham

Another gem by the Davies brothers, gatesmiths of Croesfoel, displaying their great skill with wrought iron. The brother Robert is usually attributed with their design and making. Edward Hubbard comments, 'A beautifully frothy *clair-voie* with much scrollwork. Central pair of gates, side wickets, and short screen lengths,

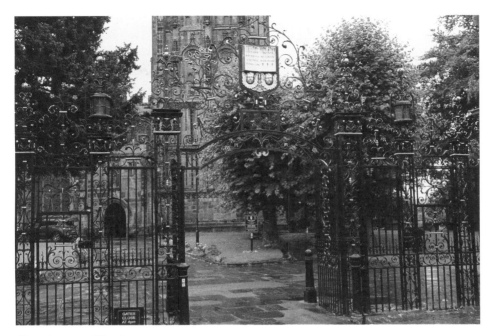

Church gates, Wrexham.

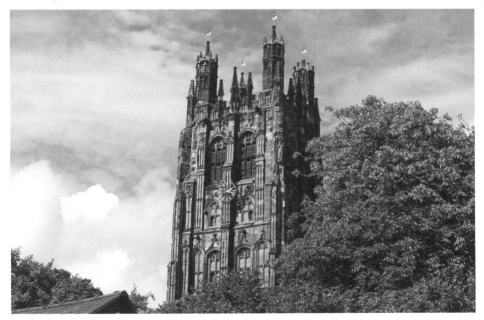

all separated by two-dimensional piers. Each portion has its own overthrow. Pair of rusticated PIERS with urns.' (*Clwyd* (The Buildings of Wales), Penguin, 1986)

These gates were given to this church by Elihu Yale (according to Simon Jenkins). Behind, the majestic tower of St Giles' Church is 136 feet high.

24 The Indoor Markets, Wrexham

From its main entrance on High Street, this Butchers Market has stalls in great variety, catering for all tastes. It is a Grade II-listed building. Its façade at No. 10 High Street was designed by Thomas Penson the Younger and opened in 1848, 'in his unmistakable and cheerful Neo-Jacobean. Shaped and finialed gables, pedimented mullioned and transomed windows and oriel under the entrance arch' (Hubbard).

Thomas Penson was a pupil of architect and bridge designer Thomas Harrison of Chester. He became a Fellow of the Royal Institute of British Architects in 1848. He was county surveyor for Denbighshire in 1820. He married Frances Kirk in 1814 and lived in Overton-on-Dee. He later moved to Oswestry. In 1839, his wife inherited Gwersyllt Hall, near Wrexham, which Penson re-designed in Neo-Jacobean style, from her father. They used it as their main residence. He also designed the building in Regent Street that is now Wrexham's museum. He died at Gwersyllt in 1859.

Below and opposite: Markets, Wrexham.

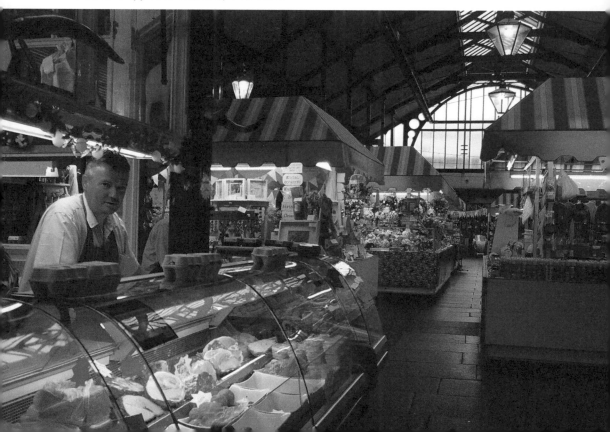

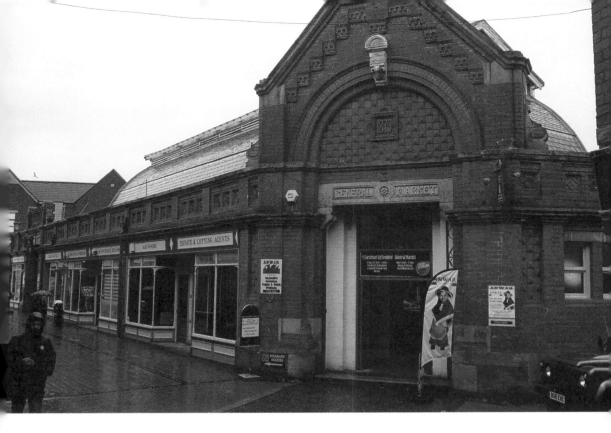

The second indoor market, the General Market of 1879, is set behind the Butchers Market, off Henblas Street, in Manchester Square. Traditionally it was busy during the Wrexham March Fairs. It is mostly occupied by clothing retailers.

25 Architecture in High Street, Wrexham

The central part, on both sides, of High Street, Wrexham, is distinguished for its stylish, assertive architecture.

The façade of the Butchers Market by Thomas Penson the Younger is an outstanding example, as is the front elevation of the North and South Wales Bank at No. 14 High Street, with its four pairs of Corinthian columns. This was bought in 1905 by the North and South Wales Bank (usually called 'the Wales Bank'). In 1908, this bank, originally founded in Liverpool in 1836, amalgamated with the Midland Bank. It was renowned for its profitability and excellence in accounting and customer care. In 1908, the 'Wales Bank' had eighty-four branches. The Midland Bank started in Birmingham in 1836 and

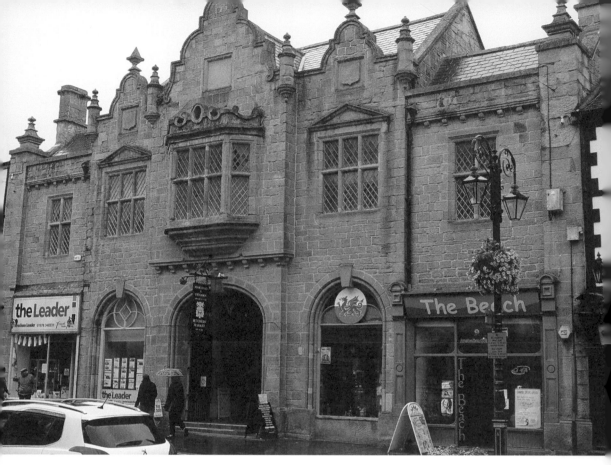

Architecture at High Street, Wrexham.

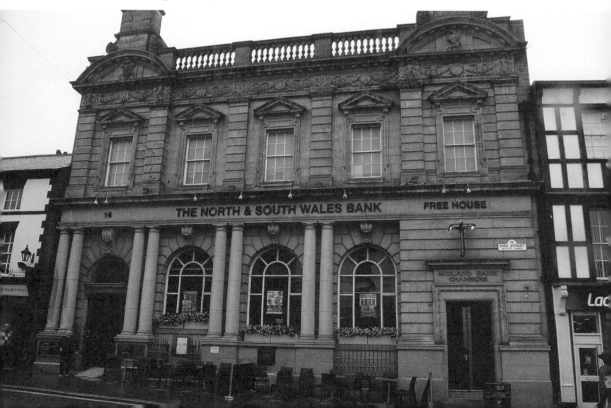

rapidly became one of the foremost banks in the UK. In 1891 it entered London. This building is currently a restaurant and pub.

A number of banking and insurance premises were built in High Street. An impressive example is the Sun Alliance building by R. K. Penson, 1860, a three-storey building. The Wynnstay Arms in York Street is two and a half storeys with an attractive brick façade.

26 St Peter's Square, Ruthin

Ruthin probably has the finest town centre in North Wales. Placed on the crown of a hill, it is surrounded by buildings of character, some dating back to the sixteenth century, others remodelled in Tudor style. There are glimpses of the Clwydian Hills.

Well Street, Clwyd Street, Castle Street and Market Street runout from here in different directions. Castle Street starts with the Tuscan colonnade of the Wine Vaults; Sir John Trevor's house has a timber-framed gable end; and Nantclwyd House is a cruck hall house with attractive sixteenth- and seventeenth-century features, with its timber-framed porch and ionic columns. The entrance lodge to Ruthin Castle closes off the end of the street.

The commanding building in St Peter's Square is the mid-eighteenth-century Castle Hotel (formerly the White Lion when the Myddeltons bought the premises in 1678). The Georgian building was created in 1773 and was the stopping point for coaches. Charles Darwin stayed here in 1831. Next to it is the Myddelton Arms, traditionally associated with Sir Richard Clough, with its three tiers of dormer windows climbing its tiled roof. Inside is part of a medieval hall house, and there is a chimney piece dated 1657 visible upstairs. On the other side of the Castle Hotel is a half-timbered building from 1925, originally the Midland Bank. It has carved woodwork and twisted chimneys.

The Peers Monument, by architect Douglas, is from 1883, erected in celebration of a local councillor. It combines a clock tower, horse drinking trough and a drinking fountain. The half-timbered free-standing building to the south side of the square stands on the site of the original courthouse of the lordship of Ruthin, ascribed to 1401. To the west is a facsimile building where Exmewe Hall once stood. This was the birthplace of Dr Gabriel Goodman, dean of Westminster and courtier/legal advisor to Elizabeth I.

Owain Glyndwr and his men attacked the town in 1400 after a quarrel with Lord Grey over ownership of land. Glyndwr declared himself Prince of Wales at Corwen and went on to establish parliaments at Harlech, Dolgellau and Machynlleth. He made an alliance with France and proposed two Welsh

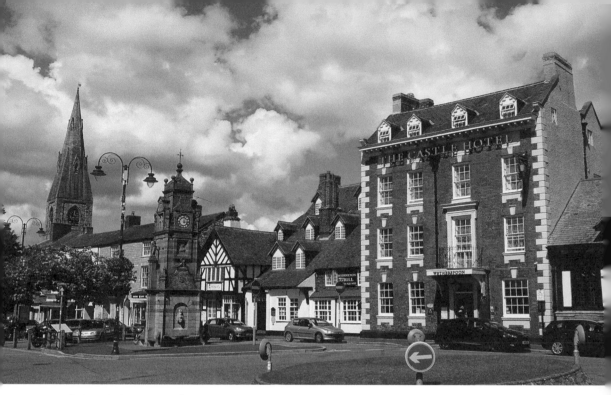

St Peter's Square, Ruthin.

universities. Shakespeare, in *Henry IV*, wrote, 'in faith a worthy gentleman, exceedingly well-read and profited in strange concealments, valiant as a lion'.

Founded in 1310 by John de Grey, the Church of St Peter included a tower. The double-nave form was added in the fourteenth century. Restoration was

undertaken by R. K. Penson in 1854–59, who added the spire. Ceiling decoration involved several families, including the Stanleys of Lancashire. The cloisters to the north are partly original to 1310, including the arches of two doorways. The original Ruthin Grammar School was located here. The church gates date from 1727, with elaborate scrollwork by Robert Davies of Ruabon. Two unusual gates stand on each side.

27 The Gates at St Peter's Church, Ruthin

'Ruthin is the most charming small town in Wales … every prospect pleases … to crown everything, Ruthin Castle … its location where the Vale of Clwyd is at its most lovely' writes Simon Jenkins in his book *Wales: Churches, Houses, Castles* (2008).

As stated previously, these gates are of exceptional quality and are a rare example of the outstanding ironwork created by the Davies brothers of Ruabon. They were restored in 1928. The gates build up to a central overthrow,

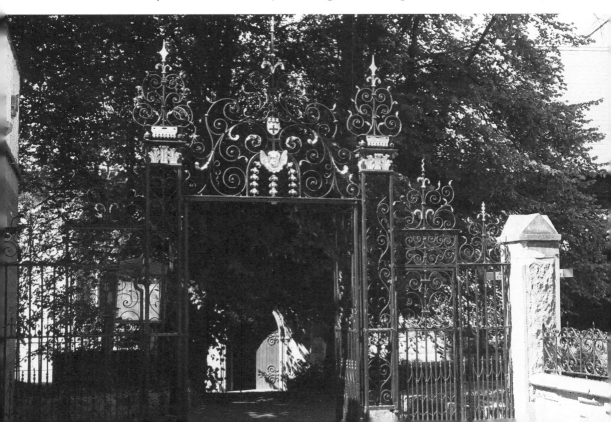

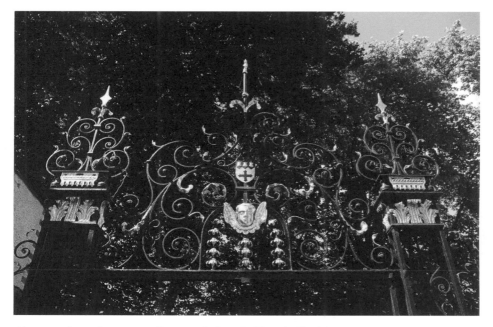

Above and previous page: Gates to St Peter's Church, Ruthin.

now freshly painted and gilded. Double gates open inwards at the centre. The image of a cherub's head between wings stands out in the centre above.

28 The Waterloo Bridge, Betws-y-Coed

This is one of the outstanding bridges of North Wales, full of historical origins. It is another example of Thomas Telford's designs. He laid down the route of the Holyhead Road through North Wales, later followed by the A5. The route through Snowdonia is a fine example of his work, and this bridge built in 1815 is robust and elegant in engineering and colourful in decoration. It sits across the River Conwy on the outskirts of Betws-y-Coed and has a span of 125 feet. In his biography of Thomas Telford, Anthony Burton writes,

> It is still possible to admire Telford's surveying skills in building the Holyhead Road through Wales, for the route is the one followed by the modern A5. The most impressive section is undoubtedly the road through

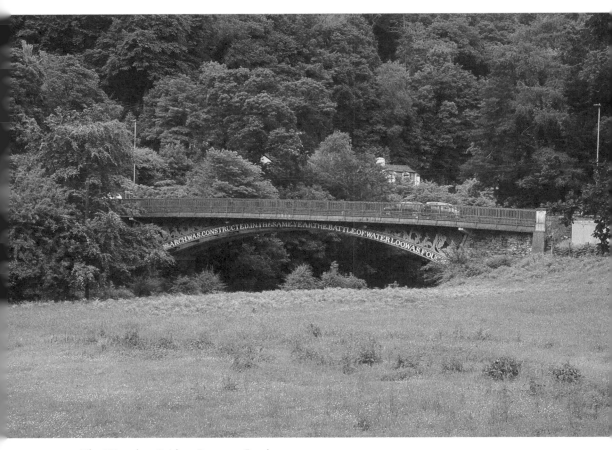

The Waterloo Bridge, Betws-y-Coed.

Snowdonia, which receives a splendid overture with a bridge across the River Conwy on the approach to Betws-y-Coed. This is an elegant cast-iron arch, springing from low abutments ... After the glorious elaboration of the Waterloo Bridge, everything reverts to the severely practical. Mountain streams are crossed by simple rubble bridges, which Telford had used in the Highlands, with no frippery.

It is made of cast iron with low fastenings in the stone bastions. The spandrels carry images of the rose, thistle and shamrock for Scotland, in celebration of the Act of Union. The words written across the arch are: 'This arch was constructed in the year the Battle of Waterloo was fought'. The master iron man William Hazeldine created the ironwork and foreman William Suttle oversaw the construction, his name appearing on the inscription on the bridge.

In 1923, the bridge was improved by the addition of a concrete deck and new footways were added. New cast-iron railing were built on the edge of the footways. It is a Grade I-listed building.

29 The Bridge at Llanrwst

The bridge at Llanrwst is one of the most elegant bridges in North Wales – an outstanding gem. It spans the River Conwy, carrying the B106 from Llanrwst to Gwydir Castle and then to Betws-y-Coed. It is narrow, suitable for only one lane of traffic, which is controlled by traffic lights.

Its design is attributed to architect Inigo Jones (1573–1652), who was born in London, the son of a cloth worker. It is said that he had local Llanrwst connections. This was stated by Thomas Pennant in his book *Journey to Snowdon* in 1781. Pennant was a trained naturalist, precise and accurate in his writings, and was very unlikely to have made up this story. Jones was surveyor of public works at the time of the bridge's construction. He was influenced by the designs of Andrea Palladio, and the design of this bridge may be inspired by his work. He may have had a connection with Sir Richard Wynn of Gwydir (1588–1649), a wealthy aristocrat who financed the building of this stone bridge in 1623, replacing an earlier wooden bridge. The bridge linked his home with the village of Llanrwst.

A. G. Bradley writes in his *Highways and Byways of North Wales*:

> But the feature of Llanrwst Church is the Gwydyr chapel … For this beautiful annexe was built out upon the south side of the chancel in 1633 by the Wynnes, once owners of Gwydyr, over yonder at the foot of the hill across the river … This mortuary chapel, which Inigo Jones seems really to have designed, is isolated from the chapel, a door being cut through the wall. It is nearly square in shape, and perhaps some thirty feet in length, and filled with tombs, mural monuments, and brasses of this potent, and, though no longer in possession of Gwydyr, still virile race. To touch upon the fantastic and sometimes beautiful work that is here, or catalogue the worthy courtiers and renowned warriors that it commemorates, is impossible…

Llanrwst's church contains a rare fifteenth-century screen, with elaborate carvings, probably brought from the dissolved Maenan Abbey. These include a pomegranate, symbol of Catherine of Aragon, dating the work to a period just before the Dissolution. The Gwydir Chapel of 1634 contains a huge stone coffin, described as originally containing the remains of Llywelyn the Great, who was buried in 1240, then reburied in Maenan Abbey. The ravages of Henry VIII caused the coffin, without its lid and human remains, to be moved to Llanrwst.

The bridge is known as The Shaking Bridge because it vibrates if the headstone of the central arch is firmly struck. Built of local stone in three arches, it is finished with sandstone. It is steep, 51 metres long and the central arch rises 14.6 metre above the river.

In the centre of the bridge are stone tablets carrying the date 1636. The plaque on the north side carries the Stuart arms and the initials CR (Carolus Rex,

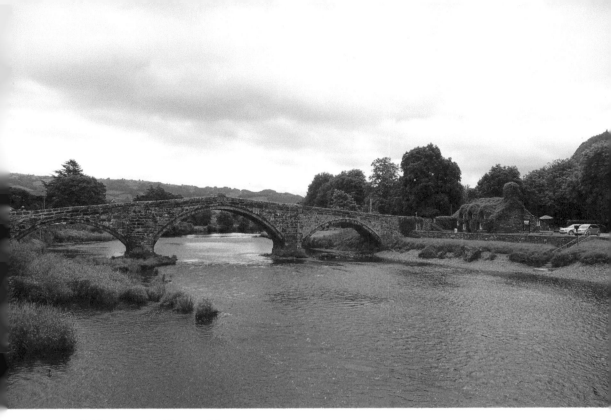

Bridge over the Conwy, Llanrwst.

or King Charles). On the Gwydir side is the stone building Ty Hwnt I'r Bont (the other side of the bridge), a fifteenth-century courthouse, which for many years has been a popular tea house.

The Llanrwst almshouses were founded by Sir Richard Wynn of Gwydir in 1610. This town was inhabited by harp makers and players and some of them lived in the almshouses. The Llanrwst Bridge is a Scheduled Ancient Monument and is Grade I listed.

30 Rossett Mill

This is a handsome, traditional building close to the main road that links the village of Rossett with Wrexham. It is close to the border with England – Chester is only 7.5 miles away. Rossett is built on the banks of the River Alun, which is a tributary of the River Dee, one and a half miles downstream.

The current building was built in 1588, and it was extended in 1688 by Sir John Trevor of Trevalyn Hall. The wheel was undershot, meaning that it was powered by water flowing underneath it. Overshot wheels, where water flows

The Old Mill, Rossett.

from above are generally considered more efficient. In 1710, the millwright Robert Kenrick executed major repairs to the house and wheel. The great artist J. M. W Turner make a sketch of this mill in 1795.

A tragic drowning happened here in 1895 to Sara Jane Howell, aged nineteen. He had suffered from fits from childhood. The verdict was suicide.

In 1973, Mike Kilganon bought the building and restored it successfully. He sold flour milled on the premises. It is a listed building, being a fine example of a sixteenth-century timber-framed undershot corn mill.

31 Swallow Falls, Betws-y-Coed

The village of Betws-y-Coed has been a magnet for visitors and artists for many centuries. Located in a central position in Snowdonia, it has been a stopping place on the A5 for travellers to the North Wales coast, Anglesey and Ireland from Holyhead. In the middle years of the nineteenth century it was much visited by landscape artists, and David Cox and Eric Gill founded artists' colonies here.

There are two forest parks in Snowdonia, in Beddgelert and Betws-y-Coed areas. They enclose camping sites, picnic sites and car parks, and visitors who treat the forests with respect are welcome.

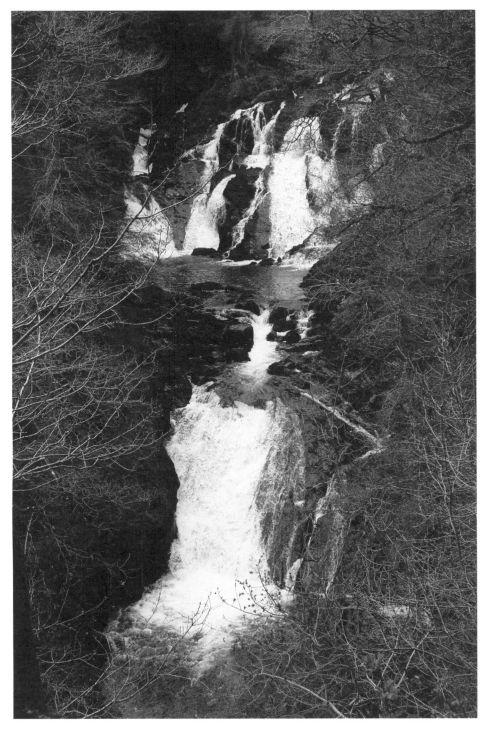

Swallow Falls, Betws-y-Coed.

Swallow Falls, on the western side of the village, contain the River Llugwy. The Welsh name is Rhaeadr Ewynnol. There is a hotel on the other side of the A5 with a car park. Access to the falls is by payment of a fee. There are steps to be negotiated with care, and a number of observation platforms. Approached along the northern bank, the path is tortuous, under overhanging crags. To show off its high flow and energy, rainfall is needed in preceding days; it is usually at its best during March and November flooding.

Sir John Wynn of Gwydyr, Llanrwst, was MP for Caernarfonshire and a justice of the Court of the Marches. Local tradition has it that he was something of a tyrant and that his spirit lives in the swirling waters of the Swallow Falls. The historian Yorke says, 'to be purged, punished, spouted upon and purified from the foul deeds done in his days of nature'.

The trees were of particular interest to the late William Condry, naturalist. He writes, 'most naturalists will turn with relief to the steep slope that takes you out of Betws-y-Coed upwards towards Llyn Elsi, for that way you go through a remnant of the old Gwydir forest, with its wild, cool, north-facing rocky wood of oak, ash, sycamore, hazel, small-leaved lime and even a scattering of yews ... probably planted by birds carrying the seeds from local churchyards or estates'.

The waterfall is a source of income for the parish council; consequently local people pay a lower sum against their property's rateable value.
(Photograph by Tom Gregg)

32 The Miners Welfare Institute, Llay

This building is an outstanding monument to the coal-mining industry, which employed thousands of men in the Wrexham district in the nineteenth and twentieth centuries. It is large and wide, with four pairs of columns and a balustraded roofline. It is accompanied by well-kept sports facilities including tennis courts, a bowling green and a cricket field. In front of the building is an old pit wheel and a pit truck on rails, holding pretend coal with a spade.

Llay was a colliery village that mushroomed after the opening of Llay Main Colliery in 1923. The site closed in 1966, was cleared and turned into an industrial estate. Llay Hall, another colliery in Cefn-y-bedd, operated until 1947. In 1966, an excavator uncovered a tusk that belonged to a woolly mammoth, a prehistoric animal that roamed Britain before the last Ice Age, around 60,000 years ago.

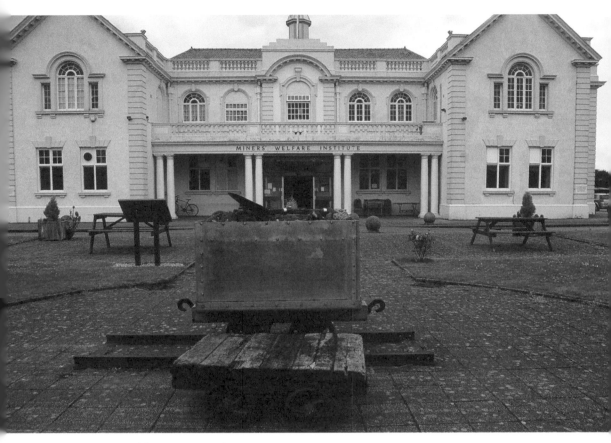

Miners Welfare Institute, Llay.

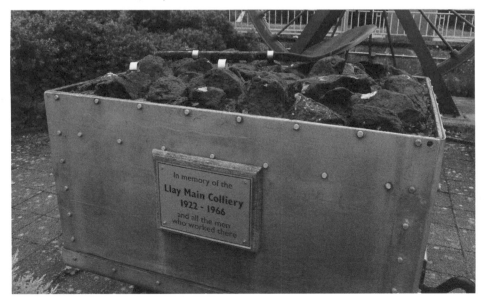

33 The Two Pubs in the Ceiriog Valley

The two public houses The West Arms and The Hand are located adjacent to the central square in Llanarmon Dyffryn Ceiriog, some 13 miles up the Ceiriog Valley, south-westwards from Chirk. Their façades are frequently decorated with flowers. Llanarmon is a small village, of much age, set among the Berwyn Mountains of northern Mid Wales. The River Ceiriog, popular with trout fishermen, runs down the Ceiriog Valley. These two pubs are well-frequented, being close to the border with central England. They offer hospitality of a high standard, with small firelit public rooms and well-made food.

Quietness, relaxation, withdrawal and a warm welcome for visitors are the keynotes here.

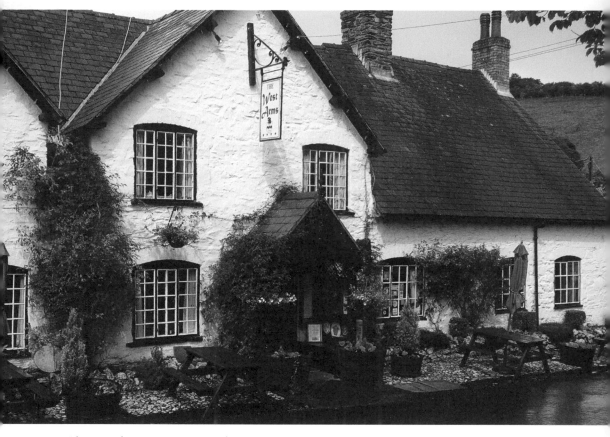

Above and opposite: Inns at Llanarmon DC.

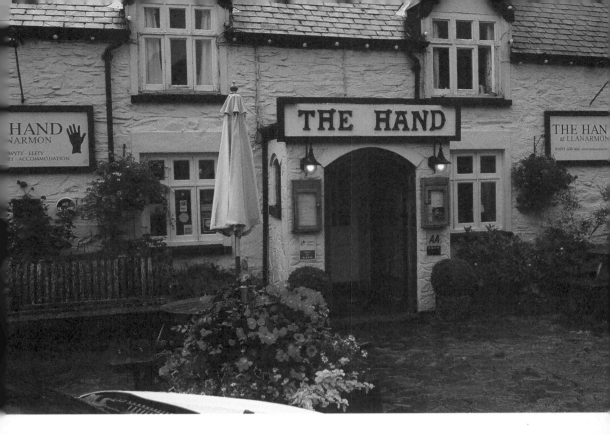

34 The Horse & Jockey, Wrexham

A remarkable public house and a Wrexham landmark with its thatched roof, rhe Horse & Jockey is a singular gem in the largest town in North Wales.

The building dates from the sixteenth century. In the next century it was divided into three residences, and repurposed as a pub in 1868. It is at No. 32 Hope Street, the side street being Prior Street.

The pub's original name was The Collier but it was renamed the Horse & Jockey in honour of champion jockey Fred Archer (1857–86), who rode at nearby Bangor-on-Dee. He had over 2,000 wins in his short life. He was 5 feet 10 inches tall – usually too tall for a jockey – but he was champion jockey thirteen times. The picture on the pub sign was painted in 1938.

Opposite the pub in Hope Street is an archway designed in 1875 by William Low of Channel Tunnel fame. Suspended on the inner wall is an informative plaque in his memory. This was the entrance to the 1876 Art Treasures and Industrial Exhibition. Inside was a covered way 78 feet long and an art gallery 130 feet long. The exhibition was overambitious and ended with a financial loss.

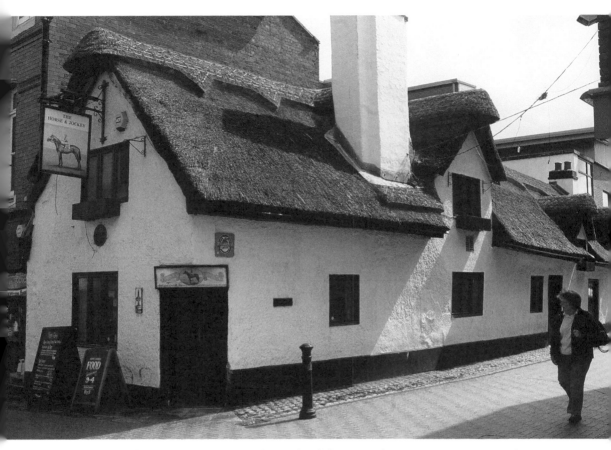

Above and opposite: Horse & Jockey and Exhibition Archway, Hope Street, Wrexham.

35 The Boat at Erbestock

Only a few miles from Wrexham, but in another world. At this point the River Dee is subdued and friendly, gently curving under overhanging trees. There is something magical about the setting. On a warm day, there is nothing better than sitting on the front lawn, sipping a drink and listening to the river.

The area goes back to Edward I of England. He obviously liked the place and tried to annex it. In 1300 a writ was issued against 'certain Welshmen' regarding lands in Overton and Erbistock. The original parish church, dedicated to St Erbin, had its roots in the thirteenth century. Nearby Eyton was mentioned in 1034.

The Boat at Erbistock.

Erbistock has two pubs. The sign of the cross foxes is an emblem of the Wynnstay family and the pub of the same name by the bridge was created as a lodging for the estate's workers. The Boat takes its name from the crossing of the river at this point; part of the ferry mechanism still exists.

The present Grade II-listed St Hilary's Church overlooking the Boat by the river is a building of nineteenth-century origin.

36 Holt Castle

Holt is on the Wales-England border. A walk down a sandstone path reveals the remaining stump of the original five-towered castle. It has an air of importance, which may be because of the significance of its location, being a few yards inside Wales from the border that runs along the close-by River Dee – it smacks of border conflicts.

This castle dates from the late thirteenth century and was strongly built. Its sense of fortification is evident. There was a barbican, inner ward and also a moat with water fed from the river. In 1277 Edward I invaded North Wales. He built this castle as a secure outpost, storing valuables here – gold and clothing. The Earl of Surrey, John de Warren, was part of the Edwardian scheme to keep the Welsh in subjection, and Holt was part of a similar scheme of marcher lordship castles of Chirk, Ruthin and Denbigh. The town of Holt was allocated to English settlers. The forces of Owain Glyndwr came in 1400 and burned down the town, although they made little impression on the small, strong castle. In the Civil War, the Parliamentarians and the Royalists held the castle at different times. In 1643 the Parliamentarian garrison were slaughtered and their bodies thrown into the moat. In the seventeenth century much of the building was taken away and used for domestic building.

Beside it, the Dee runs strongly, coming out to the sea near Chester. This makes Holt Castle an important location for bringing in merchandise by sea, and for taking it away when under threat.

The Romans were also here. They created a tile and pottery factory around AD 75, covering around 20 acres, which lasted some seventy-five years The bridge over the Dee is from the fourteenth century.

H. G. Wells taught for a short time at Holt Academy in the main street (now a private house), a nonconformist educational institution, before deciding to leave and make his career as a writer.

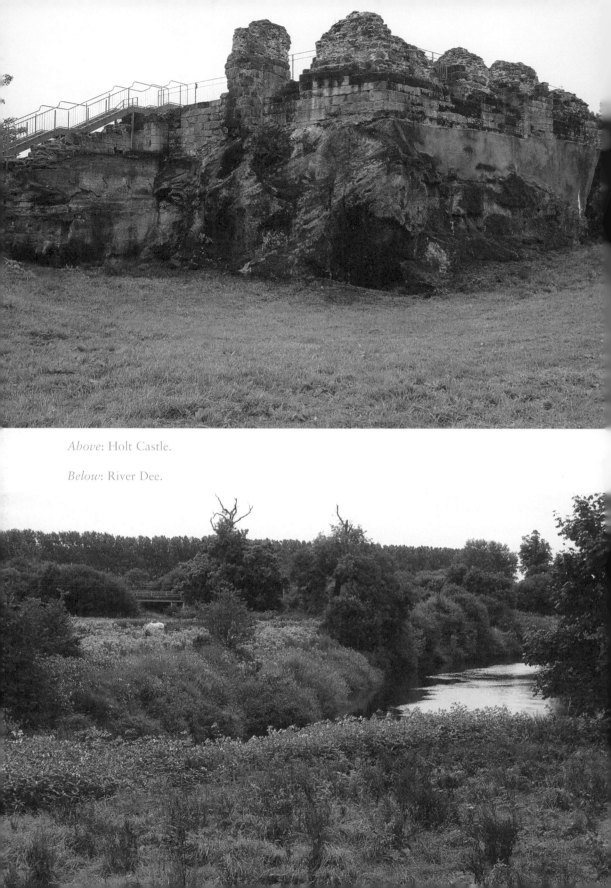

Above: Holt Castle.

Below: River Dee.

37 The Pant-yr-Ochain near Wrexham

Set by the Old Wrexham Road, Gresford, this restaurant is accessible from the edge of Wrexham along a narrow road and down a drive. The building has an air of speciousness and significance. Its rolling lawn faces a lake in the grounds. In the late twelfth century it was a Welsh settlement under Owain Gwynedd, in the tribal area called Powys Fadog.

This place, or part of it, was originally built in the 1550s as home for the Almer family. It was later bought and enlarged by Sir Foster Cunliffe in 1785. Most of the building now used as a restaurant is from the eighteenth century.

It is popular with diners, who enjoy its wide views and gardens.

Above and overleaf: The Pant-yr-Ochain, Wrexham.

38 The Trevor Arms, Marford

You cannot miss Marford as it has the most distinctive architecture. Its windows
stand out for their small panels and the black pointed framing above them, and
its doors are reminiscent of illustrations in children's stories. It is remarkable
that the village exhibits this characteristic styling, which is called Gothic Revival.
It mostly dates from the late eighteenth century, as part of the work done by
the Trevalyn Hall estates, especially the Boscawen family. George Boscawen
described the Marford style as 'romantick gothick'. The cottages originally had
thatched roofs, later replaced by Welsh slate. Some houses have crosses built in-
to their design, said to repel bad spirits and ghosts. The Trevor Arms is a homage
the landowning Trevor family of Trevalyn Hall.

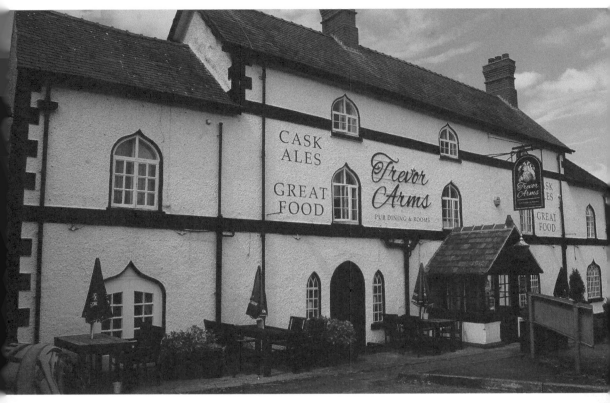

Above: The Trevor Arms, Marford.

Below: Domestic architecture, Marford.

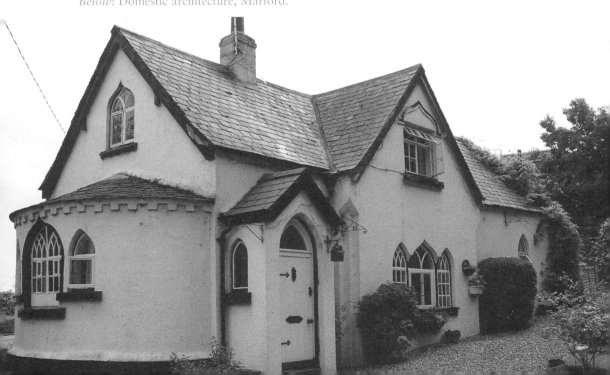

39 Chirk Castle

(One of Simon Jenkins's Top Thirty Buildings of Wales)

A monumental structure built as a fortress and set on the crown of a hill to the west of Chirk, this castle commands wide views, guarding the entrance to the Berwyn Mountains at the Ceiriog Valley. In Welsh it is Castell y Waen. Before this building, there was a stronghold here known as Crogen. Border warfare occurred in and around this site, and the Battle of Crogen took place at the mouth of the Ceiriog Valley between Henry II and Owen Gwynedd, Prince of North Wales. Owen had succeeded in uniting all Wales and was opposed by the Norman leaders. An old historian wrote, 'Prince Owen was there with his brother Cadwallader and all the strength of North Wales; Prince Rhys with that of South Wales, Owen Ceifeilioc and Madoc ap Meredith with the power of Powys.' Henry advanced from Oswestry with an army of Normans and French.

Its origin is in the late thirteenth century, built by Roger Mortimer, Justice of North Wales for Edward I. It was one of a chain of castles created across North Wales. The famous James St George was the designer. There are similarities with Beaumaris and Harlech castles.

The castle and its lands were sold for £5,000 to Sir Thomas Myddelton, scion of an ancient Denbigh stock, in 1595. He was one of the founders of the East India Company. He sponsored the expeditions of Raleigh, Drake and Hawkins and became Lord Mayor of London in 1613. His brother was the founder of the New River Company. The Myddelton family lived at the castle until 2004.

Fitzalans, Mowbrays, Beauchamps, Nevilles, Stanleys and finally the royal Tudors, in the shape of Henry VII himself, became lords in turn of this historic and commanding fortress until the Myddelton Bidulphs took over in the sixteenth century.

Sir William Stanley, appointed Justice of North Wales by Richard III, occupied Chirk Castle. However, he betrayed his master at the Battle of Bosworth in 1485, and the victor, Henry Tudor, as Henry VII, made him Lord Chamberlain and a Knight of the Garter. However, William was executed by Henry in 1495 when it was discovered that he was party to a plot to overthrow the King. Elizabeth I gave the lordship of Chirk to Robert Dudley, who became Baron Denbigh.

In 1801 the castle passed to the Bidulphs by marriage. In 1845–48 the famous A. W. N. Pugin worked on improvements. In 1978, the Myddeltons gave the building to the Secretary of State for Wales.

The castle is now owned by the National Trust and is open to the public at certain times. It has extensive gardens, clipped yew hedges, herbaceous borders and terraces. It has a long, curving access drive.

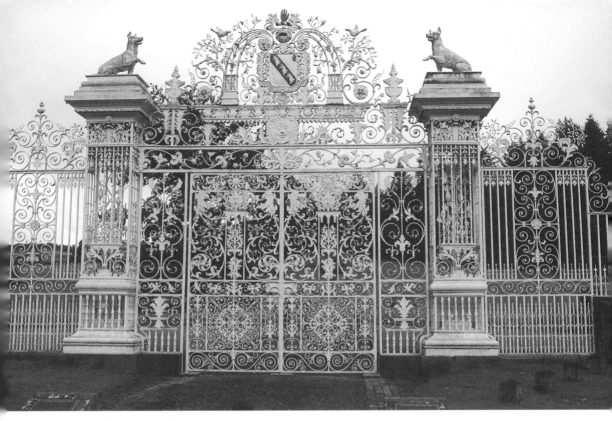

Chirk Castle and gates.

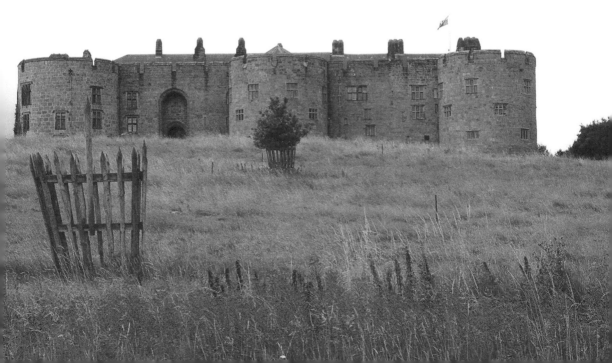

The huge gates are the work of the Davies brothers Robert and John of Croesfoel Forge, Bersham, created in 1719. They carry the coat of arms of the Myddelton family. They were originally meant to be situated at the forecourt of the castle, but were later moved to their present site. The palisades on either side were meant to enclose the castle forecourt. The 'bloody' hand of the family design is presented next to eagles' heads. The bloody hand has created a number of stories involving the cutting off of a hand: one says that it originated with the impression in blood on a white cloak worn in battle by one of the family.

The lodge, in Tudor style, was built in 1888.

40　The Ceiriog Valley

Culminating in Llanarmon Dyffryn Ceiriog, this is spectacular scenery. The road from Chirk, the B4500, twisting and turning for some 13 miles, follows the River Ceiriog until the valley comes to an ending at this charming village. 'Remote' would be a fitting adjective. The first settlement is Llwynmawr, then Pontfadog, Glyn Ceiriog, Pandy, Tregeiriog, and finally Llanarmon DC. From here, the mountain road travels to Llanrhaeadr-ym-Mochnant, a few miles from which is the Pistyll Rhaeadr, the tallest waterfall in England and Wales.

Below and opposite: Glyn Ceiriog.

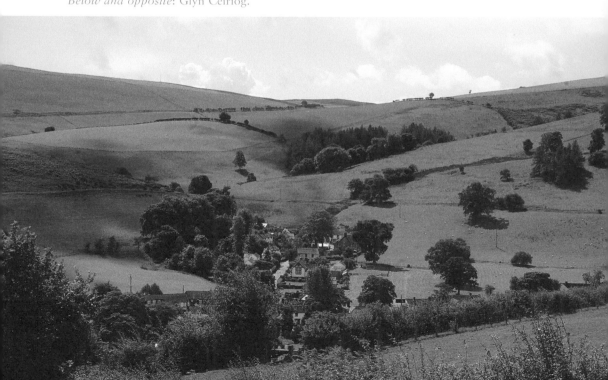

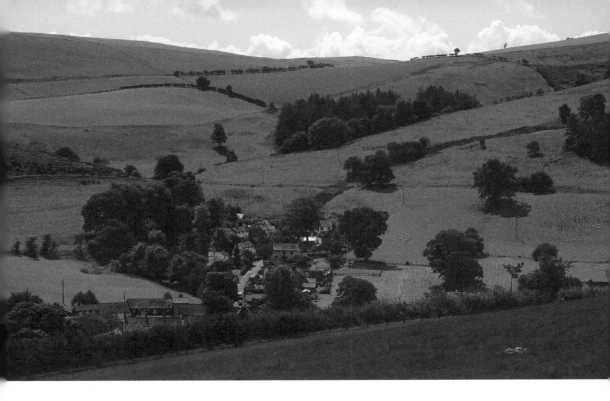

According to research conducted by BBC Radio in Cardiff in the 1960s, this area was the last region in Wales to include residents who conversed in Welsh and could not speak English.

The Berwyn Hills, and Mountains, are tall, some over 1,500 feet. Moel Fferna, to the north, is just over 2,000 feet; Mel Wen is 2,200 feet.

Llangollen lies to the north, Oswestry to the east, Bala to the west and Llanfyllin to the south.

41 Dulyn Reservoir, Dolgarrog

Dolgarrog is located around halfway between Llanrwst and the town of Conwy, on the River Conwy. To the west is the wild and beautiful Snowdonia region under the name 'Carneddau'. Its tallest mountain is Carnedd Llywelyn, 3,485 feet above sea level, which is a few miles south of the Dulyn Reservoir. The River Dulyn runs eastwards from here to join the Conwy.

The name Llywelyn is attributed to the Welsh leader Llywelyn the Great, whose monument can be seen in Llanrwst Church. However, it is sometimes attributed to his grandson, Llywelyn the Last, who was murdered on the orders of Edward I and whose severed head was displayed on a spike at the Tower of London.

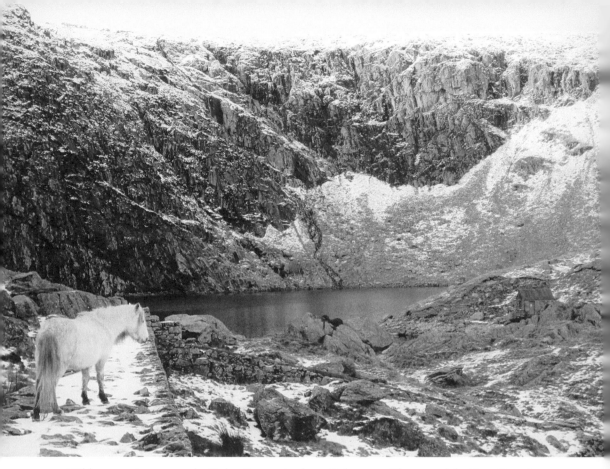

Wild mountain pony at the Dulyn Reservoir above Dolgarrog. (Photograph by Tom Gregg)

In November of 1925, a flood of water caused by the failure of two dams caused the deaths of sixteen people in Dolgarrog – 26 inches of rain had fallen in five days. The UK parliament reacted by passing the Reservoirs (Safety Provisions) Act of 1930. The local pub, the Lord Newborough, suffered damage in the flood and later closed for business.

Lake Dulyn is in the centre of the Carneddau range. It is very deep, at about 200 feet, and black, up against a rock face some 500 feet high. It is said that as many as twenty aeroplanes have crashed in the Dulyn area, and the lake sometimes reveals part of a propeller above its surface. The rocks around the lake have particles of abrasive quartz embedded in them, which is said to have been used as a sharpening tool for agricultural implements in Victorian England.

William Condry writes,

For Bronze Age man we can go five miles west of the Conway to the vicinity of Llyn Dulyn where, on a south-facing slope at about 1,700 feet, are the copious Dartmoor-like traces of hut-circles and cairns and a bewilderment of walled enclosures and what look like terraced fields. This valley-head right under the Carneddau may strike you as a

sodden, lonely and unkind place to have settled to till the earth. But if in Bronze Age days the climate was warmer and drier than todays, then the upper Dulyn Valley could have been a delightful habitat for man even in winter. The name of this spot is Pant yr Griafolen – Roman-tree Hollow, a name, perhaps a very old name, that recalls trees that have long since gone.

42 The Street Market, Mold

North Wales has many street markets, but few are as good as the one in Mold, which takes place on a Wednesday and a Saturday. It is in two locations. The variety of goods offered is extensive. Many of the stallholders have been trading here for over twenty years and have a close and friendly relationship with their customers. The couple selling caps and watches in our picture will replace the battery in your watch in a few minutes for a low price. Bedding, china, flowers, plants and shrubs, fruit and vegetables, domestic

Below and overleaf: Street market, Mold.

implements and tools, and much more are available. It is a spectacle, and very popular.

Mold is overlooked by St Mary's Church, which is designed in the Perpendicular style. It was enhanced by work financed by Margaret Stanley well into the Reformation period. The interior roof is decorated with Tudor rose panels. Richard Wilson, the Welsh painter, has a grave inside the east wall.

43 The Cefn Viaduct

This spectacular construction is the second to fly over the River Dee, only a mile downstream from the better-known and much-visited Pontcysyllte Aqueduct. The difference between the two is that the latter carries a canal and towpath, and can be negotiated across by narrowboat and by foot. The Cefn Viaduct carries only a railway line, and has no foot crossing.

The best way to admire this remarkable construction is from the Cefn Mawr country park, which has facilities for visitors including goats, donkeys and goats, and is well signposted from the Wrexham-Ruabon road.

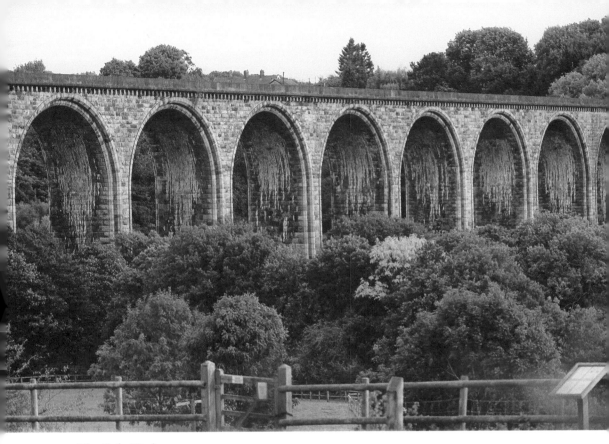

The Cefn Viaduct.

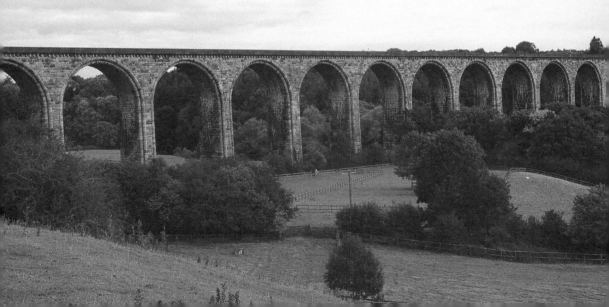

It measures 1,508 feet in length and stands 147 feet above the River Dee. It has nineteen arches each spanning 60 feet. It carries the railway line from Chester to Shrewsbury, and despite its great age, the train service runs multiple times daily on a safe platform.

Its origin dates back to 1845 when schemes were put forward to run a railway from Chester to Shrewsbury. Henry Robertson described how such a line would strengthen the economic ties of the area. The viaduct was built quickly and opened in 1848. The railway contractor Thomas Brassey was commissioned to construct the viaduct.

Henry Robertson was a Scotsman born in Banff. He studied at Aberdeen University. He came to Wales, revived the Brymbo Iron Works and became MP for Shrewsbury in the 1860s and '80s.

Thomas Brassey was a railway man through and through. By 1847 he had built a third of Britain's railways. He also built railways in France, Australia, Canada, India and other countries. He designed and built the structures associated with railways, and built part of the London sewage system, which is still working today. He was a major shareholder in Brunel's *Great Eastern*, the only ship large enough to lay the first cable across the North Atlantic in 1864.

44 The Chirk Telford Aqueduct

When the Pontcysyllte Aqueduct was being built, a second aqueduct was being planned for Chirk. Telford and Jessop shared their ideas.

There are two spectacular bridges at Chirk: the aqueduct and the railway viaduct, which is taller and built behind it on the Ceiriog Valley side.

Telford wrote, 'Aqueduct is situated in a fine wooded valley, having Chirk Castle as an eminence immediately above it, the Welsh Mountains and Glyn Ceiriog as a background and the village of Chirk with Lord Dungannon's Ceiriog Bridge occupying the immediate space. These combined objects complete a landscape seldom surpassed.'

This Chirk aqueduct is 70 feet high, built between 1796 and 1801 by Thomas Telford and William Jessop to carry the Ellesmere Canal. There are ten circular masonry arches each spanning 40 feet. It does not copy Froncysyllte in having a cast-iron trough carrying the water; there are bolted-together iron plates with side walls of local stone. The water level is 70 feet above the River Ceiriog. A railway viaduct was later built alongside this aqueduct, taller than the latter structure, to show, it is said, the superiority of rail transport.

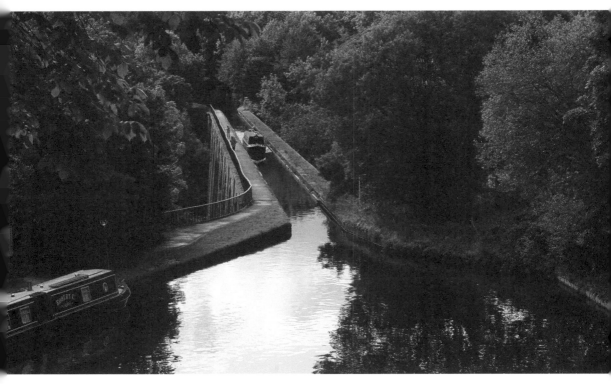

Above: The Chirk Telford Aqueduct.

Below: The Chirk Telford Aqueduct with the railway behind. (Courtesy of Andrew under Creative Commons 2.0)

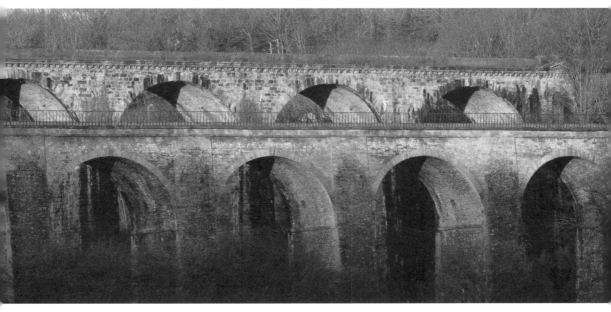

45 The Vale of Clwyd

This valley opens to the sea at Rhyl, having created a trough over some 20 miles with the Clwydian Hills to the east and the Hiraethog Moors to the west. On the shoreline sit Rhyl and Prestatyn, and a little further inland, Rhuddlan, then Abergele, St Asaph, Denbigh and Ruthin. It is geologically distinct, being of glacial formation, with Triassic sandstone below, forming an underground lake, framed by impervious rock. The earth here is very fertile, being the only Grade 1 agricultural land in Wales outside the Vale of Glamorgan.

St Asaph contains the ancient cathedral where William Morgan, translator of the Bible into Welsh, was dean. Rhuddlan has a defensive castle, with castles in Denbigh and Ruthin. The last named dates from 1277, and was part of the cantref of Dyffryn Clwyd held by Edward I's ally Dafydd ap Gruffydd, brother of Llywelyn The Last. In 1282, Dyffryn Clwyd was granted to Edward de Grey as the new marcher lordship of Ruthin. Ruthin's church was founded by Reginald de Grey in 1310. The third Lord Grey of Ruthin was part of a quarrel with Owain Glyndwr, who in 1400 attacked the town at the start of his ten-year uprising through Wales. The English Civil War laid the castle to waste. The earliest part of the domestic building was built in 1846 for Frederick West and his wife Maria, who was a Myddelton heiress. The Cornwallis-Wests then lived here; they were known in Edwardian society. In 1920, the building became a private clinic, with building additions. Dr Gabriel Goodman is Ruthin's most important person: he became Dean of Westminster and created the new English version of the Book of Corinthians, and he was also one of Elizabeth I's principal courtiers.

To the east of Ruthin is the village of Llanbedr-Dyffryn-Clwyd, overlooked by Foel Fenlli (1,676 feet above sea level). Along the line of the Clwydian Hills is Foel Famau (to the east of Denbigh) at 1,817 feet. There are ancient hill forts including Moel y Gaer and Penycloddiau.

Denbigh has more listed buildings than any other town in Wales. It was home to many significant people, including Hugh Holland, whose name is in the preliminaries of William Shakespeare's *First Folio* of 1623. Sir Hugh Myddelton was a banker, goldsmith and engineer. He brought fresh water to London by cutting a canal 38 miles long from Ware to Islington, which significantly improved the health and well-being of the citizens of London. It was opened in 1613 when his brother Sir Thomas was Lord Mayor of London, where he was MP. Hugh was MP for Denbigh for twenty-five years.

The famous poet Gerard Manley Hopkins lived in Tremeirchion, to the east of Denbigh, in the Jusuit retreat St Beuno's College from 1874 to 1877. Here he wrote some of his major poems including 'Pied Beauty'. The following two lines illustrate the view from Tremeirchion down to the floor of the Vale of Clwyd:

> Landscape plotted and pieced – fold, fallow and plough;
> And all trades, their gear and tackle and trim.

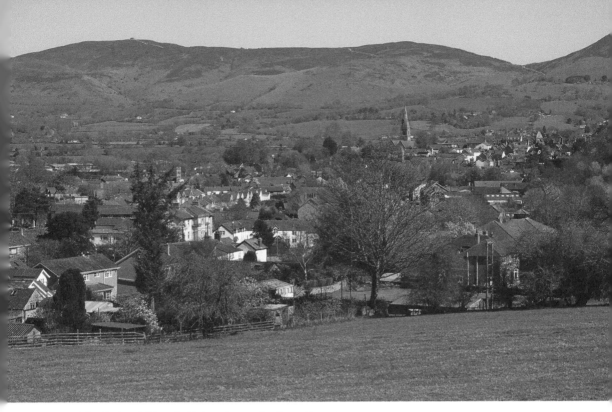

The Vale of Clwyd. (Below image by Tom Gregg)

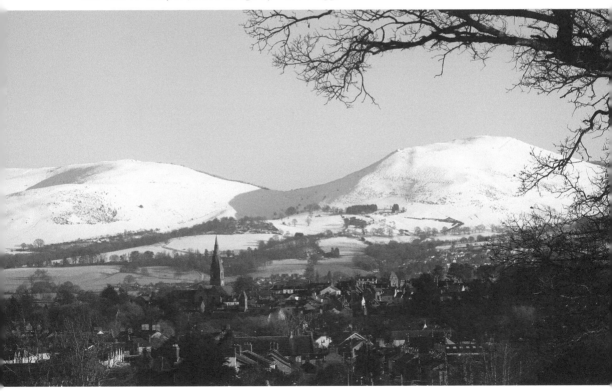

Not far from Tremeirchion is Llangynhafal. Half a mile from the village is its church and the half-timbered, well-preserved house Plas-yn-Llan. This is where Robert Jones, William Wordsworth's Cambridge friend, was brought up. His father was vicar of the church and a lawyer in Denbigh. After graduating, the two friends went on a European walking tour. In 1793 Wordsworth was here, his sister writing that '[he was] sitting down in the Vale of Clwyd'. He had stayed here earlier in 1791, and later in 1824. The earlier visits were lengthy, covering some six months. It was from here that Wordsworth set off to climb Snowdon, described in his long work *The Prelude*.

Beatrix Potter was another Denbigh connection She had relatives at Gwaenynog (on the mountain road to Pentrefoelas) where she created a garden that was the setting for the first of her Peter Rabbit stories.

Another literary figure who graced the area is the famous war poet Wilfred Owen. He had his home in Birkenhead and when he was twelve years old he spent part of August 1905 as a holiday guest of the Paton family at their farm Glan Clwyd, at Rhewl, between Ruthin and Denbigh. He wrote in a letter 'I can count up to 10 in Welsh and have learnt a few expressions.'

Kate Roberts, the Welsh novelist and short-story writer, lived in Denbigh for some forty years. Her foremost novel is *Traed Mewn Cyffion*, translated into English as *Feet in Chains*.

Historically, socially and geographically there are strong links going back to the late Middle Ages between the Vale of Clwyd, especially the Lordships of Denbigh and Ruthin, and the governing classes in London.

46 The Bay of Llandudno

Great Orme's Head is, at its highest point, 679 feet above sea level (in Welsh it is Pen Gogarth). Its name is derived from the Viking name for a sea monster. It is made of limestone, the strata clearly visible when viewed from the seashore. To the east, the other side of the curving beach, is Little Orme's Head. Both look over Conwy Bay and Liverpool Bay. To the east lie Penrhyn Bay and Colwyn Bay, and to the west are the Conwy Sands, which lie outside Deganwy in the estuary of the River Conwy, with the castle and town of Conwy on the opposite bank. There is a second beach situated on the Conwy side of the peninsula, which is accessible on the western edge of Llandudno.

The town of Llandudno is well known for its many hotels and guest houses. They occupy the coastline in numbers and enjoy the open aspect and the sea air. Consequently, it is a Mecca for visitors and tourists – some

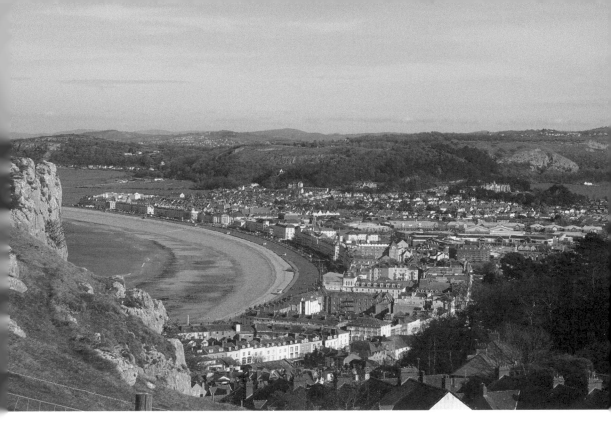

Llandudno.

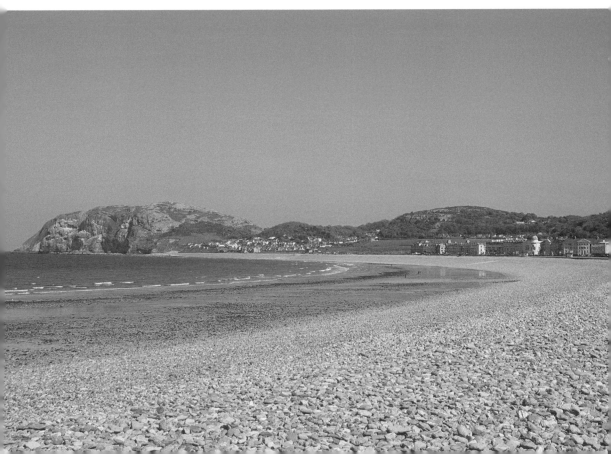

holidaymakers stay for weekends and weeks. It is said that there are more beds for visitors in Llandudno than there are in the whole of the rest of North Wales.

For the children, there are donkey rides on the beach and Prof Codman's Punch and Judy, established in 1860, and the longest pier in Wales. Above them is the 350-million-year-old rock. The most exhilarating way to travel up the Orme is by cable car, which starts from near the Happy Valley behind the pier. It is the longest cable car ride in Britain, travelling at 6 mph over just over 1 mile – the continuous steel cable is over 2 miles long. The sitting down taking-it-easy route is by tramway. This travels on rails and again offers spectacular views. Look out for the Kashmir goats with their long white shaggy coats and fearsome horns. The Bronze Age was a long time ago, but they were human too. They dug away at the rocks here looking for copper and any useful or flashing mineral – you can follow their tracks at the Bronze Age Mine. The Summit Visitor Centre has interactive and audio-visual exhibits, and you can play at the Rocky Pines Adventure Golf. You can take your car around the Orme on a road trip of 4 miles.

Turning to the bay, we notice its elegance, fitting the name 'Queen of the Welsh Resort'. Although the area goes back to the thirteenth century and the manor of Gogarth, in the time of Edward I the bay itself and its buildings are comparatively recent. It started to develop in the 1840s when Lord Mostyn, the landowner, followed the advice of Owen Williams, a surveyor, and started turning marshland into a holiday resort. This was given impetus by the opening of the railway to Llandudno Junction and Deganwy in 1858. George Felton was the leading architect and most of the shoreline ('Parade') buildings were designed by him. The pier was built in 1858 and is a Grade II-listed building.

47 The Tower of St Giles' Church, Wrexham

This is one of the Seven Wonders of Wales. The rhyme reads:

> Pistyll Rhaeadr and Wrexham Steeple,
> Snowdon's mountain without its people,
> Overton yew trees, St Winefride's well,
> Llangollen Bridge and Gresford bells.

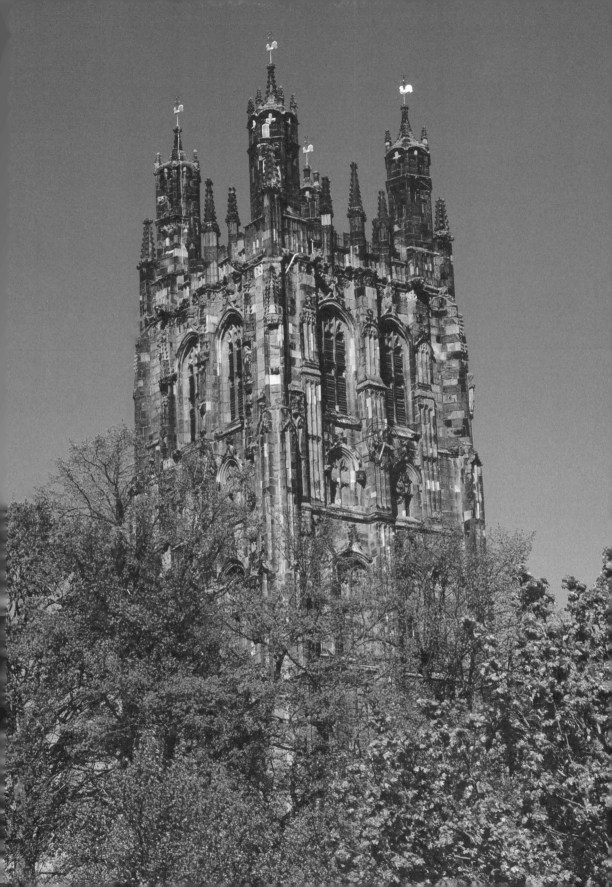

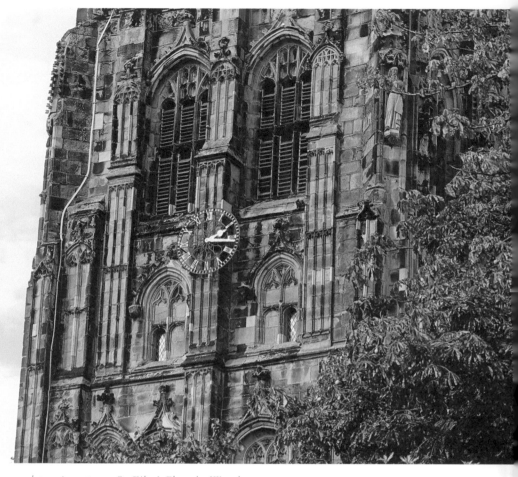

Above and previous page: St Giles' Church, Wrexham.

This ditty was supposed to have been written around 1800 by a visitor to North Wales. The rhyme is mistaken as the church has no steeple.

This sixteenth-century tower certainly overshadows, and it can be seen from miles around, being 135 feet tall. It has an inscription of 1506. Its top has pinnacles and parapets similar to Gloucester Cathedral. There are sixteen subsidiary pinnacles, and the buttresses give an impression of strength. There are thirty niches, most containing sculptures.

This church is a Grade I-listed building, described by Simon Jenkins as 'the glory of the Marches'. At 120 feet long with four hexagonal turrets, it is the longest medieval parish church in Wales. It was remodelled in the late fifteenth century by Thomas, Lord Stanley, and his wife Margaret Beaufort, mother of Henry Tudor (Henry VII).

Elihu Yale is buried within a few feet of the base of the tower, and a replica was constructed at Yale University, USA, in the 1920s.

48 The Horseshoe Pass, Llangollen

A beautiful landscape, the road curving and bending as it traverses from its height near Llandegla down to the Vale of Llangollen. The golden tones of the gorse and heather are particularly striking in the autumn.

The Welsh name Bwlch yr Oer Nant is descriptive, meaning 'pass of the cold stream'. 4 miles in length, it has a height of 1,368 feet, with an average gradient of 5 per cent. Its top level is not protected by roadside metal structures, making it dangerous – especially in icy conditions. Many accidents have occurred here, with vehicles skidding off the surface and falling down the steep edge. It comes between Llandysilio Mountain and Cyrn-y-Brain. Sheep and wild ponies are free to roam and care needs to be taken to avoid them. Created in 1811, the road from the top affords a long view of Llangollen. Edging the road at its centre point is a long pile of slate remains from the quarrying of the nearby hillside, which contains slate.

Above and previous page: Horseshoe Pass, Llangollen.

49 Conwy Castle

(One of Simon Jenkins's Top Thirty Buildings of Wales)

Dominating the town and the River Conwy, this castle is outstanding in its architecture. It speaks of power and authority, and, some would say, arrogance. It echoes the castles at Harlech, Caernarfon and Beaumaris as part of Edward I's attempts, between 1283 and 1289, to dominate North Wales and subjugate the native Welsh. Edward's large army came from Chester and Montgomery and captured Aberconwy in March 1283. He refounded the local Cistercian Abbey at Maenan, 8 miles up the River Conwy.

By 1287 after resolute and extensive stone setting, the building of Edward's castle was complete. Gangs of masons gathered in Chester and walked into Wales. The height of the walls of the town were of a height, which matched the height of the castle. The castle's constable was supported by a royal charter of 1284, and became the mayor of the town. His castle contained thirty soldiers with fifteen crossbowmen.

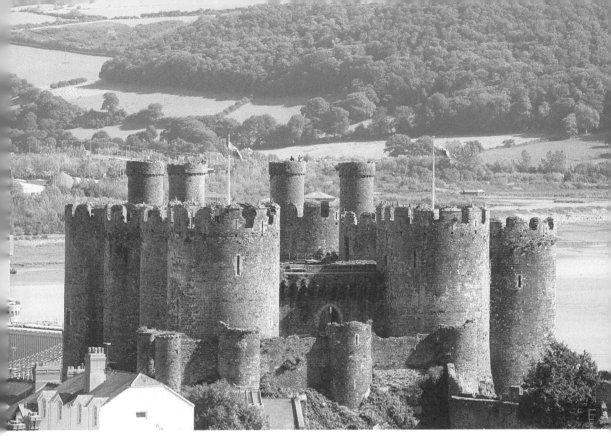

Conwy Castle. (Above image by Tom Gregg)

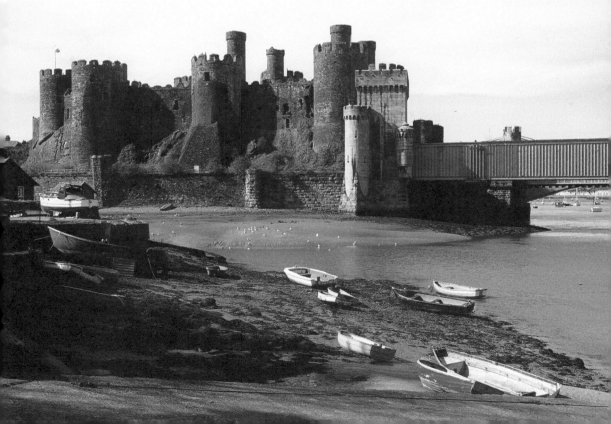

In 1294, Madog ap Llywelyn and his Welsh men attacked and Edward was besieged in the castle, supplied by sea, until he was rescued in February 1295 by fresh English forces.

Edward II came in 1301 and received homage from the welsh leaders. In 1343, the Black Prince took control. Henry Bolingbroke attacked in 1399, and Henry Percy caused Edward to surrender at Flint castle.

In 1401, forces loyal to Owain Glyndwr held the castle for several months, but were pardoned by Henry Bolingbroke – Henry IV. Henry VIII conducted restoration work in the 1520s. In 1642, during the English Civil War, the castle was held by Royalist forces, but gave in to Parliamentary forces. In 1665, much of its lead and iron was stripped.

UNESCO has stated that the castle at Conwy is 'the finest examples of late 13th century and early 14th century military architecture in Europe' and is given the status of being a World Heritage Site. Dominating the River Conwy, this is a defensive site of strength. It has an inner and outer ward, having large rounded towers and two barbicans, and an entrance on the riverside, allowing supplies to be brought in from the sea. Inside are medieval royal chambers. The Savoy architect/stonemason James of St George was responsible for the design and execution.

Artists have often depicted the castle. J. M. W Turner was here, and also Paul Sandby and Moses Griffith. The town and castle of Conwy is much visited and over 186,000 persons visited the castle in 2010.

50 The Golden Lion at Rossett

This local public house is typical of such establishments found all over North Wales. Our picture shows the well-kept flower display on the frontage facing Chester Road.

Rossett is a friendly village 'where everybody knows one another'. Situated between Wrexham and Chester, the area is richly agricultural.

There is a ghost story related to the Golden Lion. In 1776, a man John Thomas (also known as John Jeffry) was accused of robbery and attempted murder. He was hung and subsequently gibbeted on a structure on land opposite the Golden Lion.

We have his ghost here, but he is friendly. He is said to occupy an upstairs room and sometimes emerges, moving chairs and sitting on a chair below the beams in the bar area.

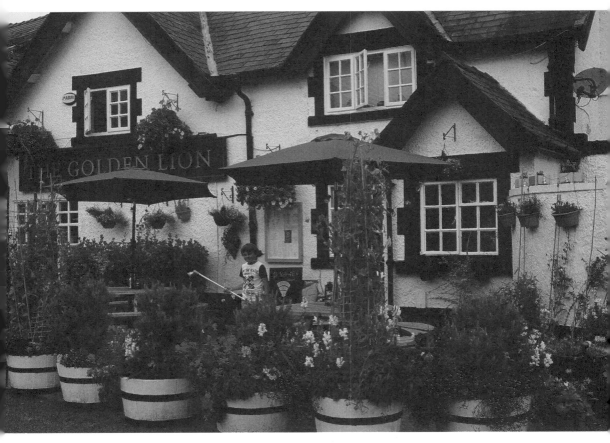

The Golden Lion, Rossett.

Also available from Amberley Publishing

Explore Wrexham's secret history through a fascinating selection of stories, facts and photographs.
978 1 4456 7700 2
Available to order direct 01453 847 800
www.amberley-books.com